POINT & SHOOT
Getting the Best from Your Compact

D1414633

PHOTOGRAPHING WILDLIFE AND NATURE

LIZ WALKER

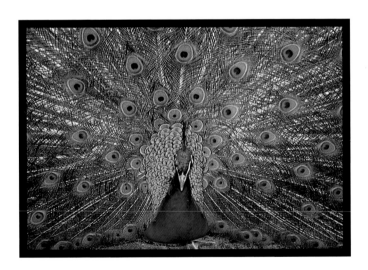

Amphoto Books, an imprint of Watson-Guptill Publications/New York

Contents

First published in the United States and Canada in 1996 by Amphoto Books, an imprint of Watson-Guptill Publications, Inc., 1515 Broadway, New York, NY 10036

Edited and designed by Hamlyn, an imprint of Reed Consumer Books Limited Michelin House, 81 Fulham Road, London SW3 6RB

U.S. Editor Robin Simmen
Commissioning Editor Julian Brown
Editorial Assistant Humaira Husain
Design Tony Truscott Designs
Art Editor Valerie Hawthorn
Picture Researcher Wendy Gay
Production Melanie Frantz

Library of Congress Cataloguing-in-Publication Data Walker, Liz, 1966 Photographing wildlife and nature / Liz Walker.
p. cm. – (Point & Shoot)
ISBN 0-8174-5541-8 (pbk.)
1. Nature photography – Amateurs' manuals. 2. Wildlife photography – Amateurs' manuals. 3. Electric eye cameras – Amateurs' manuals. I. Title. II Series.
TR721.W337 1995
778.9'32--dc20 95-26090
 CIP r95
Produced by Mandarin Offset
Printed in Hong Kong

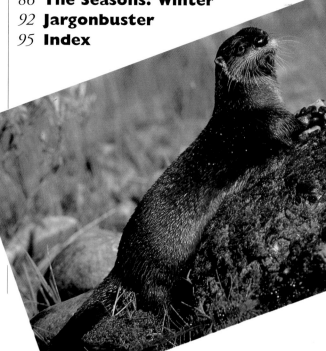

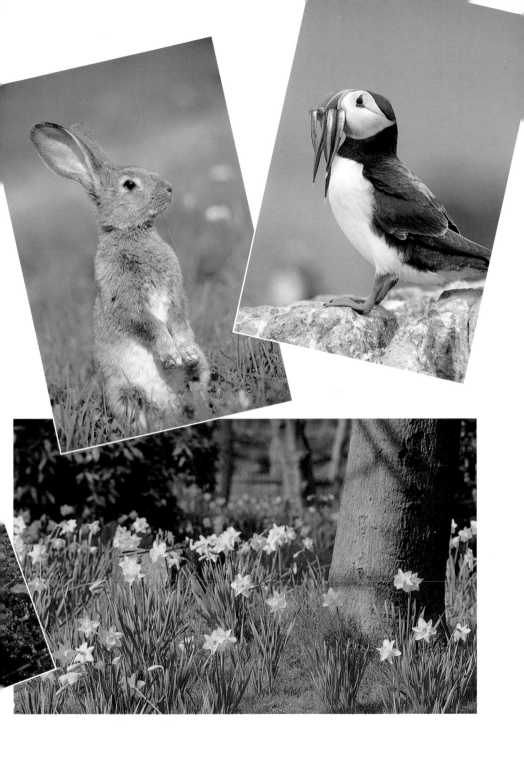

Introduction

Barely a day goes by without some new threat to our environment, or another creature added to the list of endangered species. It's small wonder we're all becoming very conscious of the world around us, and the need to conserve and protect the living plants and creatures which inhabit our planet.

The sophistication of wildlife TV programs has whet our appetite for pictures. This book is aimed at those people who already appreciate the awe-inspiring beauty of the natural world, but who also want to go out and take pictures of these magnificent things for themselves.

Although many subjects lie outside the scope of the zoom compact camera (for instance, very small insects and very timid species), there's a wealth of more approachable subjects which will tolerate human beings hiding within a blind. All you have to do is prepare yourself with knowledge of your subject, and your camera and you should meet with success.

However, at all times, pay strict attention to the wellbeing of your subjects: leave only footprints, and take only pictures.

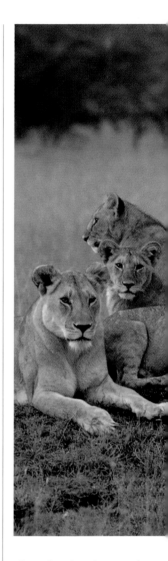

On safari, this photograph of a pride of lions could easily be within your grasp with a compact camera.

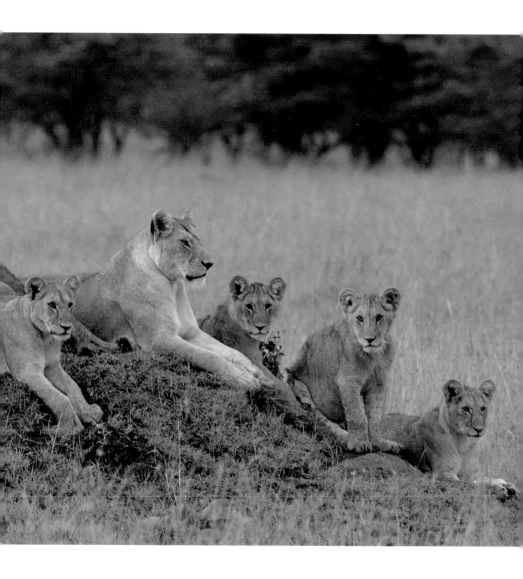

Planning

The natural world is full of wonderful surprises and discoveries: the fascinating transformation of caterpillar into butterfly; plants unfurling their petals at sunrise and close them again at dusk; the dramatic sight of migrating birds flying in close formation. Such photogenic marvels all lie within the grasp of the informed compact-camera user, but, to photograph nature well, he or she must set some aside time to prepare.

After rain in wet sandy locations, paw prints and tracks are a sure indicator of animal presence, such as these gull prints (below) and turtle tracks (bottom).

Know your subject The chances of coming across a wild animal by accident are slim but you can improve them by learning about different species – their habitats, food, mating and breeding practices, and lifestyles in general.

Two important sources of information are reference books and visual-identification guides. A good library has a host of such books and you can soon build up a special project file, of lifestyle and behavior details for each animal you wish to photograph. It may seem laborious, but it will be worth it.

Finding wild habitats Maps are useful for locating wild areas. Novice nature photographers can seek potential subjects often at local wild areas which is more useful for them than researching a distant area, even though it might have more exotic species.

Well-tramped woods bursting with dog-walkers on a Sunday are not as useful to a nature photographer as a deserted reservoir, a fallow field or abandoned railway sidings. But even the most popular canal towpaths, woods and parks offer some wildlife potential at times like a quiet weekday.

If you are not keen on the idea of solitary reconnaissance, take a quiet companion with you.

Looking for clues Take a pair of binoculars to your chosen area to watch the undergrowth and tree-tops; listen carefully for bird calls and rustling bushes and sniff the air for unusual scents. Dusk is a good time for the wildlife sleuth, just as nocturnal species start foraging for food.

Take your research notes along with you. From your reading, you will have found which trees, fruits and nuts attract which species of birds and squirrels, foxes and badgers.

Do's & Don'ts

■ Do try to visit sites where there are known to be rare flora or fauna, national parks or bird sanctuaries, all marked on detailed maps.

■ Don't head straight for a wilderness expecting to get full-sized images of rare birds and animals. Start off practicing on more accessible, tame species in the garden.

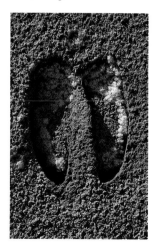 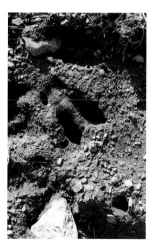

Study naturals history books to determine the species which the tracks belong to, so you can tell them apart. These tracks show the presence of elks (far left) and deer (left).

Picture Pointers

■ If you cannot get close to a wild animal, you can generally enlarge a small section of the film frame if you use ISO 50–100 film on a bright day and the picture is sharp. Ask a photo laboratory about selective enlargement and show them which area of the print you want to magnify.

RIGHT Warm dark or neutral coloured clothing is ideal for hunting wildlife. A map case will keep your maps clean and dry.

BELOW Sensible walking shoes are a good investment.

A small hole in the ground may be the entrance to an animal's burrow; check the surrounding earth for paw prints and trees for clawing. Look also for gnawed nuts – a sure sign of a squirrel in the tree above. In more remote open spaces you may even find abandoned carcasses: buzzards, owls, foxes and other carnivorous predators may be hunting near.

Get up early after a rainy night to check for paw prints in mud or sand in your chosen area. Gleaning as much useful knowledge as possible about it will pay dividends when you are out baiting and waiting for your quarry.

The right clothing You need to be determined about searching for wildlife, venturing out at night and throughout the year. Always keep yourself warm and dry and avoid clothes which rustle or are too visible.

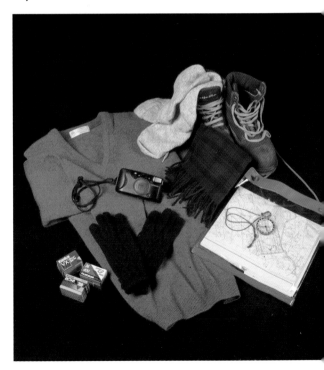

Planning

LEFT *Waterproof jackets can rustle and disturb your subject so use them for reconnaissance trips only, when you don't need to get very close.*

ABOVE *Use a good pair of binoculars for reconnaissance, but remember that your camera's lens may not offer such strong magnification.*

Stick to green and brown clothes, unless it is snowing or you are tackling a barren coastal area.

Thermal underwear and a good pair of walking shoes make a lot of difference stalking wildlife in winter, and waders and rubber boots are useful, especially if you fancy a few underwater pictures mid-stream.

Camera Skills

■ Use a quiet but long zoom lens; muffle it with a scarf (removed once the lens has extended).

■ In macro mode, useful for small subjects at close-range, check the subject in the viewfinder's guide markers.

Camera accessories For sharp pictures, you need either a flash or a camera support. With wildlife photography, flash is not generally the answer. It is better to use a tripod or beanbag to hold the camera still, switching off the flash if your camera has an override facility.

Another useful gadget is an infra-red remote release, offered by some top-of-the-range cameras. This allows you to set up the camera on a tripod beside a baited area, like a bird table, and to take pictures while you watch from a distance.

A good pair of binoculars is essential, though

Trouble Shooter

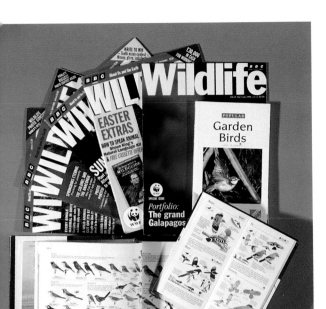

Q How can I find out if there is any wildlife in my local wood?

A It is certainly there. Whether it be worms, beetles, spiders, mice, thrushes or badgers, the way to track it down is to visit the wood frequently and get to know all the different types of habitat it offers. Sit quietly in the undergrowth to observe and take notes. Do not use scented soap or deodorant – animals will be more aware of you! Watch the ground for shrews and ground-nesting birds such as the wood warbler, robin and blackbird and check the vegetation for grasshoppers and beetles. Bark may show signs of gnawing and scratching (squirrels and badgers) and higher up in the leafy canopy you may see other birds and holes which may belong to owls.

With perseverance, you will find some wildlife to photograph.

LEFT *A camouflage covered beanbag will help keep the camera rock steady without the inconvenience of carrying a tripod.*

ABOVE *Use reference material such as widlife magazines and encyclopaedias.*

remember that your camera will probably not be able to zoom in and magnify the subject as much as the binoculars will.

Finally, remember if you are stalking wildlife to stay still and quiet. Keep spare films tucked into a pouch or up your sleeve to minimize movement when you change films.

Mastering Fieldcraft

Trouble Shooter

Q How close will I be able to stalk deer?

A It depends on how quiet and sensitive you can be. Watch for cracking twigs and rustling clothes and bushes. Set your camera's zoom to full extension before you begin. The deer will probably know you're there anyway, but, if it senses no danger, it may just stay put. One of the main problems is that the deer's own woodland camouflage may make it hard to see in the photograph. Use a more open setting in a deer park for practice.

RIGHT *An open setting allows you to see the subject more clearly though you'll have to be very patient and cunning to get close enough for a shot of a white tailed deer like this.*

Once you have some idea of the wildlife in your chosen area, start planning your photographic approach. Because they have to stay constantly alert to predators, wild animals and birds have heightened senses of sight, hearing and smell. So, if you want reasonably sized wildlife images on film, you have to be at least as sensitive as your subject. This is fieldcraft.

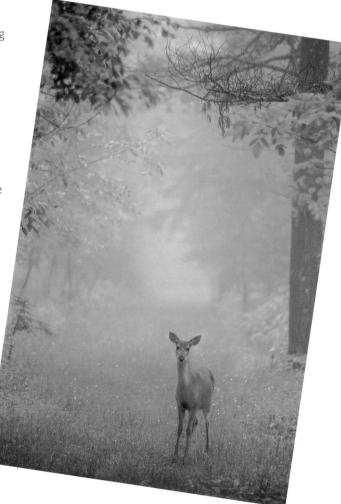

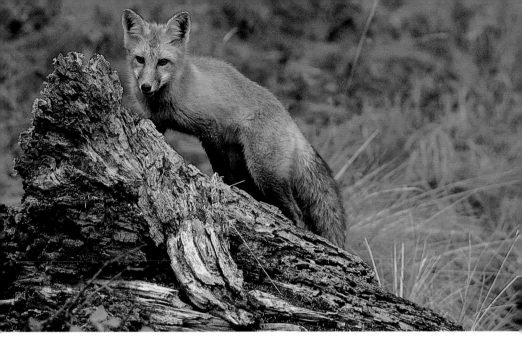

Circle of fear The larger and more timid the animal, the larger its "circle of fear." This means the area an animal feels safe in until an unknown species or predator enters it. Humans call it "personal space."

For instance, with both seals and deer it is important to take a long time, gradually creeping nearer on your stomach and avoiding sudden movements or noises. Deer will tolerate you if, like those in deer parks, they are used to humans but in the wild you must take account of their fear-circle and take a good deal of time when entering that space before taking your pictures.

Skills for stalking Though it is tempting to rush in and startle your subject with a noisy camera and flash, this is not kind. It is far better and more rewarding to stalk your subject quietly and slowly, keeping close to the ground on your stomach and muffling the camera with a sweater as the zoom lens extends.

If the animal is aware of you, let it get used to your presence before you start taking pictures. Once it is sure you won't harm it, it may let you get closer.

ABOVE *Stalking is useful for some species – others you can use a hide until the animal comes to you.*

BELOW *Herons are camera shy, so try to muffle the sound of the zoom.*

Picture Pointers

■ To get the creature to pose, you can softly click your fingers to attract its attention.

■ Have birds looking into frame from one side rather than sitting in the middle.

RIGHT *This great horned owl allowed the camera to get quite close.*

BELOW *Live traps can be baited to get small animals.*

Remember these points

1 Stalk slowly and quietly with no sudden movements
2 Avoid scented soap or deodorant
3 Keep downwind and keep a low profile – do not stand tall or break the horizon
4 Wear camouflage clothes that do not rustle
5 Muffle your camera
6 If you stalk the animal with your body low to the ground and your back to the light when it is sunny, the creature will not see you clearly. Try to avoid casting a shadow or showing a silhouette.

Humane traps It is possible to use what's known as a "live mammal trap" to catch smaller mammals, such as field mice, for photography. You must not leave the animals in these traps for very long without sufficient food and water.

Also, make a point of learning which species are protected by law, as it is illegal to trap and photograph

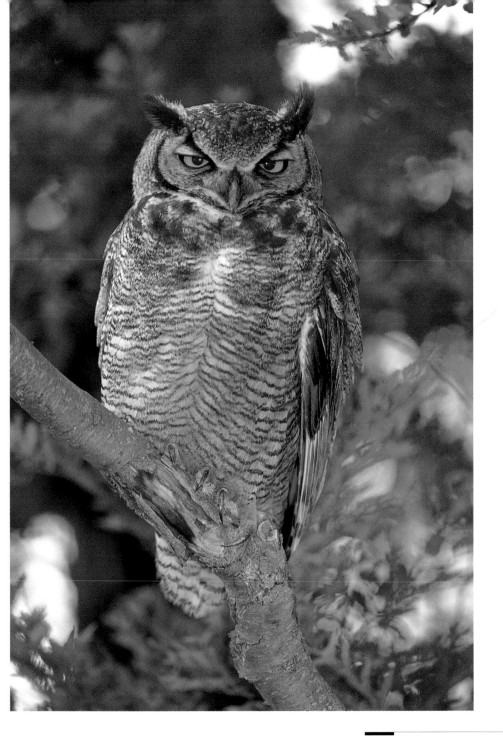

Camera Skills

■ For baiting, set up the camera on a tripod and lie in wait under cover, but switch off flash or you'll startle the subject.

■ When stalking, watch the animal through the viewfinder and wait until it looks in your direction.

■ For a live mammal trap, use a glass tank with vegetation and slip subject in so it cannot escape during the photo session. Get everything ready.

certain rare species. These could include lizards, snakes, toads; check with your local authority or nature club if you have any doubts.

Once you've trapped your subject, make the photo session short to avoid stress. Make sure there is plenty of food and water on hand and that the area mimics the creature's favorite conditions (warm or cool, wet or dry) for comfort.

Never let the photo session go beyond a couple of minutes and always release the animal into the wild where you found it.

Baiting The third method of getting close to nature and wildlife is by baiting an area with an animal's favorite food. From your research you will have learnt what your subject eats naturally in the wild, but there are some other foods which certain species really love. Badgers, for instance, have a real penchant for peanut butter!

If you put the animal's favorite food somewhere you suspect it frequents (ideally in your garden) you can bring it to a given spot with little difficulty, although baiting does require patience while the animal finds the new food and gets used to eating it. Keep the area baited regularly and you'll soon train the animal to come to you.

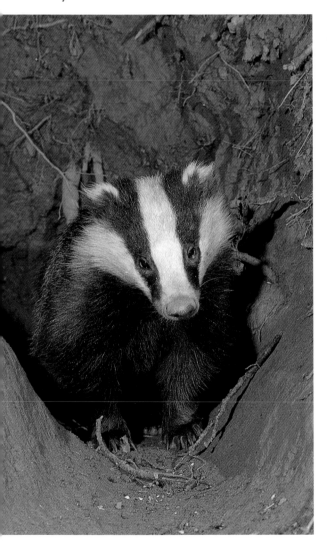

FAR LEFT *Small subjects like this chameleon can be brought indoors after being trapped. Take extreme care to make conditions pleasant – not too hot or cold, with enough food and drink. Release it swiftly after you have finished.*

LEFT *Learn which bait will attract your subject. Though large amounts are not very good for them, badgers have a penchant for peanut butter!*

Do's & Don'ts

■ Do practice your fieldcraft regularly, using garden birds as a starting point. Though your early attempts may prove disappointing, practice makes perfect.

■ Don't bait an area with food for birds unless it is safe from predators. Check the neighbour's cat wears a bell on its collar and that it cannot reach the baiting site from cover.

Garden Birds

Do's & Don'ts

■ Do muffle your motordrive with a piece of cloth to avoid startling birds if they are very close.

■ Do gather foods in autumn for use as bait later on. Acorns are easy to collect; store them in seed trays in the dark to avoid mould.

By far the easiest subjects to photograph with a compact camera are garden birds. They are close to home, easily baited, and in winter, when other food is scarce, they are less timid than usual. Many gardens offer natural food and shelter, though predators such as cats (and even larger birds, such as the sparrow hawk) can be a problem. By putting out

RIGHT *Keep garden birds such as these blue tits well fed throughout the winter and they'll pose regularly for your camera.*

food for birds in your garden in winter, you may inadvertently be setting up a new food source for the cat next door ... present your neighbour's pet with a collar with a bell on it.

Identifying your subjects Urban gardens usually attract starlings, sparrows, blackbirds and tits, while wooded gardens near countryside streams and farmland might attract all these plus more exotic species including the occasional kingfisher, redwing and swallow.

If you set your alarm clock very early and watch your lawn and surrounding trees as the sun comes up you will find that scores of birds visit your garden at this time of day, creating a real racket as they strike up the "dawn chorus." Spend time watching them with your binoculars and an identification guide to see exactly what species they are.

Next, find out what they eat, so you can lure them to part of your garden for photography.

ABOVE *Ground feeding birds like to use an elevated look out perch before flying down to feed.*

Camera Skills

■ Remote control photography allows the camera much closer to the bird feeder than usual. Birds get used to it (providing you switch the flash off and use a tripod instead) though they remain wary of humans. You need a camera with a short-range remote control transmitter.

Garden Birds

FAR RIGHT *Perches help you set up your shots in advance, focusing on the perch and making sure the background is not too distracting.*

Picture Pointers

■ Wait for the bird to sit in profile before releasing the shutter, as this way you'll have sufficient depth of field to keep the image sharp.

■ Working from close range or with remote control, you may find the camera's built-in flash helps to pick out the subject's eye, making it look more alive. This is especially useful for birds with black head-caps and black eyes.

RIGHT *Finches feed from bird tables, whilst blackbirds prefer the ground. Wait for them to show you their profile, looking into frame before taking the picture.*

Types of feeding stations Not all birds like to eat in the tree from nut sacks; wild birds have varied feeding methods. Blackbirds and thrushes are principally ground-feeders and the best way to attract them is to scatter the food on the ground. Robins, starlings, finches and sparrows readily take to a bird table or feeder, so set up a perch near the table which they can use as a look-out post and you can use as a focusing point.

Bird tables are best used for scattering seed and

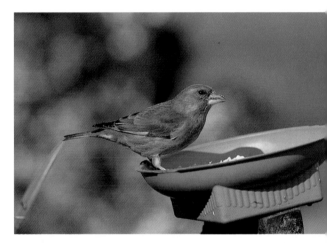

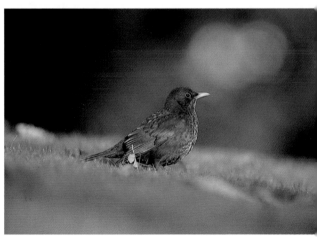

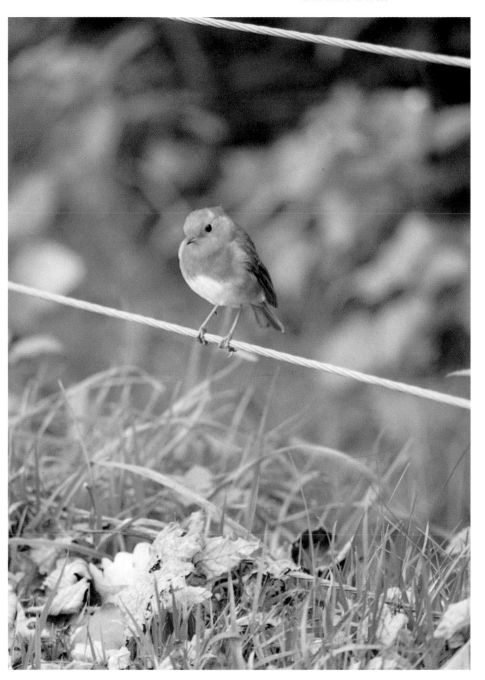

Trouble Shooter

Q Is there a food shopping-list for garden birds?

A Yes! This is it, for the next time you are out on a woodland walk or visiting local shops.
■ Acorns and hazelnuts – jays and squirrels.
■ Peanuts – nuthatches, tits, woodpeckers, sparrows and starlings.
■ Worms, insects, and snails – thrushes, blackbirds, martins and swallows, wrens, warblers.
■ Wild bird seeds – buntings, robins, finches, starlings and sparrows.
■ Corn – pheasants, ducks, pigeons, doves, and finches.
■ Sultanas, currants and raisins – robins, blackbirds, and thrushes.
■ Suet, fat, apples and fruit – tits, woodpeckers, nuthatches, and flickers.
■ Tadpoles and small fish – herons, kingfishers.
■ Carrion – magpies, crows, hawks, buzzards, and owls.

breadcrumbs. While many small birds (such as nuthatches, finches and members of the tit family) prefer to feed by perching on a hanging nut sack. Woodpeckers, nuthatches, and flickers feed on the trunks of trees, so you can attract them by pasting suet or fat onto the bark of a log or tree.

Positioning the feeder When positioning your nut sack or bird table, take account of both predators and of the birds' need for water – keep a shallow saucer of water filled for bathing and drinking. A metal nut dispenser will deter squirrels from raiding the nut supply and a bird table positioned in the middle of the lawn, away from a shrubby border, will prevent cats from sneaking up on the birds.

Perches Many birds like to use a special look-out post where they can sing or watch the food, check it is safe and wait their turn. This is usually a branch or fence post and it makes a useful spot for photography to vary pictures of birds eating.

Nesting boxes It is a good idea to offer the birds a safe, wooden nesting box for spring, nailed to a tree and out of the way of cats and larger predatory birds (such as owls and sparrow hawks). These can be bought or made with sturdy plywood, though they need to be well insulated and waterproof. Take your pictures from indoors or from a home-made hide or blind (see Chapter 8) so you can use your zoom at full extension for close-range pictures, timing the shot to catch the young as they start their first flying lessons. Do not disturb the birds at the nest as the adult birds may desert their young.

BELOW *Sparrows and blue tits can be encouraged to nest in your garden, but take care to clean them out in between the breeding seasons.*

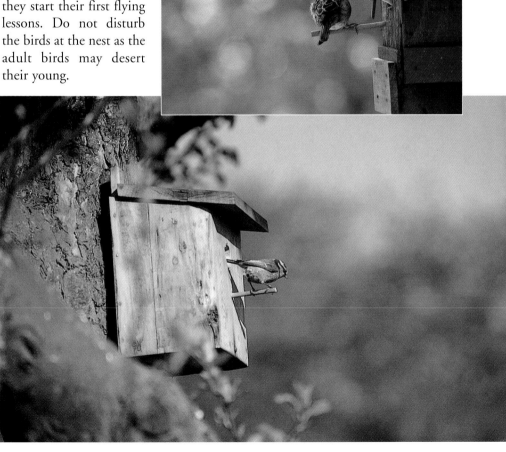

23

The Wild Coast

Do's & Don'ts

■ Don't get so carried away shooting rockpools that your forget the incoming tide. Take a tide timetable with you.

BELOW *Wait for interesting behavior, like this puffin stretching his wings before, taking the shot.*

Few habitats are as harsh and extreme as the coastline. Constantly changing, buffeted by wind and waves, silted up with sand and mud, it seems unlikely that so many different species should find homes among the salty bays and sheer cliffs. For the photographer, remote stretches of the shore should be investigated outside the holiday season. Most species here are dependent on the sea, although at low tide it leaves some of them exposed.

Seabird colonies Certain coastal nature reserves are home to a plethora of seabirds such as puffin, cormorants, herring gulls, and species of tern, nesting in colonies on cliff sides and rocky outcrops off the shore. Contact the nearest wildlife trust (a local library should have the phone number) or harbor master to check if boat trips are organ-

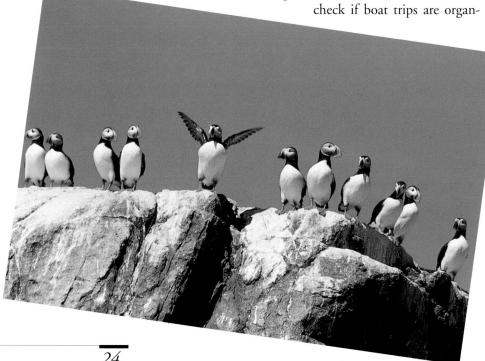

LEFT *Solitary birds can make stunning portraits. Stand or crouch to find a vantage point with the background filled with either water, cliffs or sky to avoid distraction.*

Trouble Shooter

Q How can I keep my camera protected on the coast?

A The coast is a hostile place for cameras: salt sea-spray and wind-blown sand can be a big problem, so avoid taking the camera out when a storm is picking up! Keep the camera in its pouch when not in use and keep a dry chamois leather to hand so you can clean off water droplets. Try to load fresh film where sand cannot enter the back of the camera as this will scratch the film and ruin the inner transport mechanism.

ised to off-shore colonies and whether members of the public may land there.

Some colonies are so densely packed with roosting seabirds that you cannot fail to get a good picture from close range. Stick to the path, and avoid disturbing the birds. For pictures of birds in flight, try to isolate one that is relatively still, hovering off the cliffs on a warm air current. If your camera offers exposure

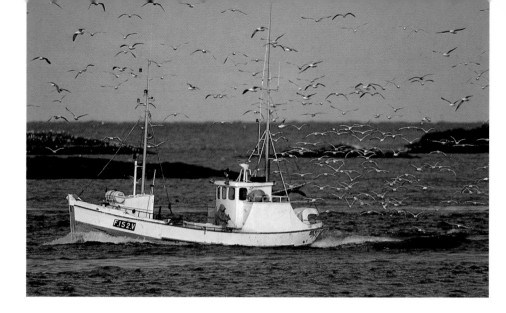

ABOVE *Watch fishing boats bring their catch to the harbour – scavenging seabirds can't resist.*

compensation, you can use it here to avoid silhouetting the subject against a bright sky. Otherwise, concentrate on the birds which are not back-lit by the sun – make sure the sun is behind or to the side of you when you take the shot.

Other coastline birds include the wading oystercatcher, which hunts for shellfish and worms in the shallows, probing the soft sand with its long beak. It looks wonderful if you catch it probing its reflection in the wet sand; if you cannot get near enough for your zoom, compose the image so the bird is isolated as a small, dark, solitary figure occupying one of the bottom corners of the frame, looking into shot.

BELOW *Comb the coast for interesting shells. Here a large colony of mussels is exposed at low tide.*

On the beach Look out for seaweed, crabs, beached jellyfish and limpets clinging to rocks at low tide. Wave patterns and animal prints make interesting abstract images if you point the camera straight down from above. In bright sunshine, you may find that the wet sand is so brilliant it deceives the

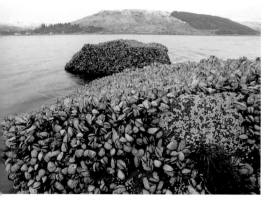

camera into underexposure, so try to add an extra stop of exposure compensation if you can.

Dunes are an important aspect of our heritage coastline, with plants such as marram grass which has roots that bind the sand to form the dune. Stabilized sand banks allow other plants to grow in their shelter: blue and pink forget-me-nots, speedwells and vetch.

Seals and otters Seals are large mammals, and there are various types to be seen on the coastline. The gray or Atlantic seal is the largest, measuring up to nine-and-a-half feet. They can be seen basking in the Western Isles of Scotland, or on islands off the north-east cost of America. The harbor seal, with its spotted coat, is also frequently seen in these waters. The common seal is, paradoxically, less common, preferring to bask in estuaries and on tidal sandbanks), bearing their young from May to June.

Though they can move swiftly and elegantly in water, they are clumsy on land: just the same, if you're stalking one with your camera, you have to be

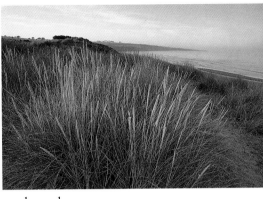

ABOVE *Freeze gently swaying tufts of lyme or marram grass with a quick burst of flash, or wait for the breeze to drop.*

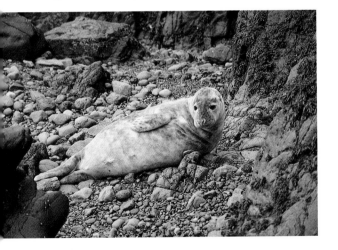

LEFT *Stranded gray seal pups are easy prey on land as they can't move very fast. Be careful not to startle them.*

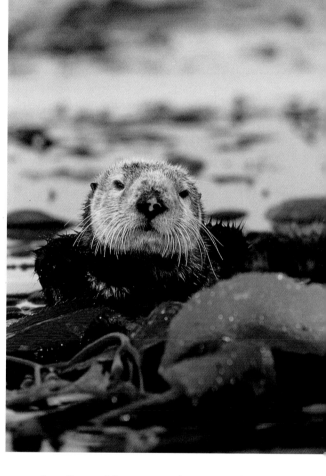

RIGHT *Otters are fast moving playful creatures. If you live near the coast, build a blind or hide to enable you to get closer.*

Picture Pointers

■ To emphasise sand ridges and shell textures, wait until the tide is out in the morning or evening. Midday light is too hard and flat, the shadows too short, to provide any relief or strong colour-saturation. In the morning, low-angled sunlight will reveal the troughs and ridges as a pattern of shadows and highlights.

exceptionally stealthy to get close. Use the zoom to magnify a group of them as much as possible from a distance, keep low and use the cover of rocks to sneak up on them. You may find their mottled grey flanks camouflage them extremely well. Wait for one of them to look at the camera for a "now you see me, now you don't" picture!

Unlike seals, which live in communities, otters are playful but solitary, secretive creatures which feed on eels, trout, salmon, frogs and crayfish. If you chance upon them you will have to be very quick to get a good shot: freeze their antics in the water with flash or fast ISO 400 film.

Rock pools Rock pools are nature's own aquarium – small pockets of water left behind when the tide goes out. Most of their inhabitants prefer to shelter under rocks or fronds of seaweed but an open pot of fish paste placed strategically in the open will soon bring the tiny crabs and fish out to feed on it. Attach a mirror at 45° to a long stick to investigate all the inaccessible nooks and crannies. The most common species are shiny, black mussels; limpets with their textured conical shells; pink forests of coral weed; hermit crabs; sea anemone; brown bladderwrack; snails; winkles and stranded predator fish, such as blennies and gobies.

This underwater jungle can be photographed either by using your existing camera inside a watertight plastic housing (available from specialists); by using a cheap, single-use waterproof compact; or by using a specially-made underwater compact.

Whichever approach you take, you cannot look into the viewfinder when you take the picture. Therefore you need to measure the distance between the camera and subject to make sure it is not so close to the lens that it falls under the minimum focusing distance (often around 20 inches with the camera in Macro mode). Also, check that the subject is positioned near the bottom of the frame. This avoids accidentally cropping the top through parallax error, which occurs when what you see is not exactly what the lens captures.

Camera Skills

■ When taking pictures of rare flowers on the beach, do not uproot them to avoid a cluttered background! Instead, keep a piece of sky-coloured card on hand so you can slip this just behind the subject.

■ On a dull day or when the plant is back-lit, use fill-in flash to boost the colors.

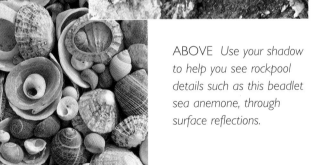

ABOVE *Use your shadow to help you see rockpool details such as this beadlet sea anemone, through surface reflections.*

LEFT *Don't forget you can bring some of your seaside subjects home for a nature study still life on your kitchen table.*

Urban Parks and Ponds

These days, the vast majority of people live in towns and cities, so getting close to nature is more difficult for them than for their country cousins. However, parks and urban wildlife centres are excellent for photographing creatures such as squirrels, swans, ducks and even the occasional marauding city fox!

RIGHT *Pairs of mallard ducks make a colorful picture – the female more dowdy than the male.*

BELOW *Try to isolate a family group, adopting a low angle of view to avoid dwarfing them from the bank.*

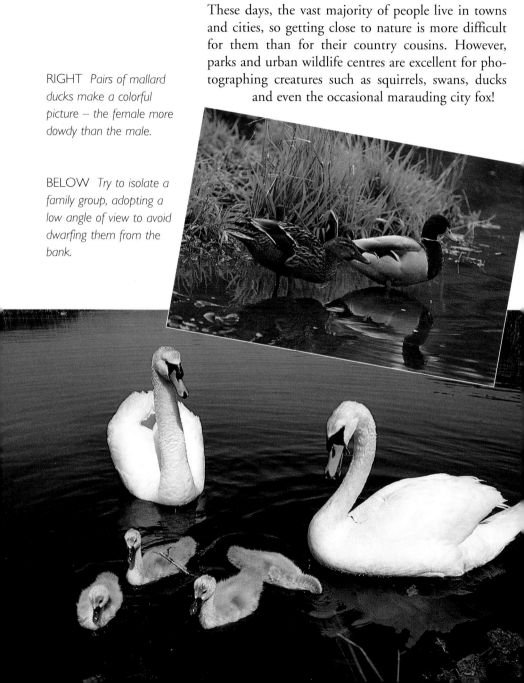

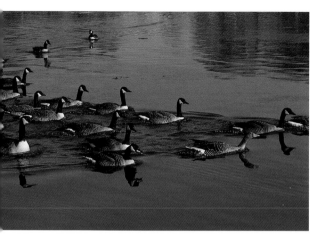

LEFT *Wait for your subjects to do something interesting such as this gaggle of Canada geese all swimming in the same direction.*

Swans and ducks Stretches of water are ideal for wildlife, provided the pond is not polluted, stagnant or overrun by algae. The easiest subjects to focus on are the swans and ducks, while neighbouring willow trees and lily pads are also photogenic.

There are many types of swan, from the mute (or royal) swan, which has an orange bill, the whooper swan, with its yellow triangular bill, and Bewick swan, which has a rounded yellow patch on its bill. Both the latter, wild, swans have straight necks and flatter wings, whereas the mute swan has an elegant curved neck and more rounded wings as it swims along. Look out for graceful reflection pictures, silhouettes and shots of young cygnets with their parents.

There are many varieties of duck, which can be seen in the wild as well as on urban ponds and lakes. They are relatively easy subjects to photograph.

Back lighting is best for pictures showing water droplets flashing in the sunshine as the adult birds rear up to stretch their wings. For detail of the plumage, meter either from the bird or from a patch of shaded water in front of it. Good timing is vital.

For a more leisurely approach, take some bread to feed the ducks and drakes at the water's edge. Get your

Do's & Don'ts

■ Don't disturb a swan at the nest. They can get very aggressive.

■ Do make regular visits to your park and check neighboring fields for signs of wildlife, too.

■ Do consult the park warden for help and advice on wildlife in the park. He may know of species that you haven't seen, and he may allow you special access out of hours for dawn and dusk photography.

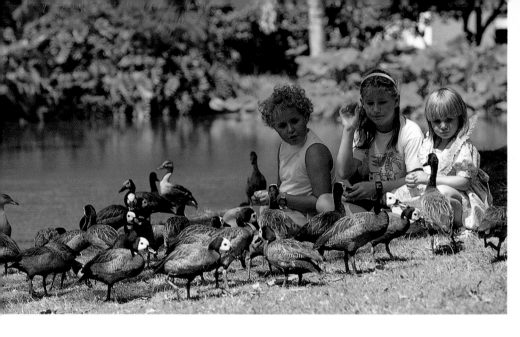

ABOVE *Bring a bag of bread for your subjects, to encourage them to hang around.*

child to lure them to the bank and wait until all the birds are looking up at the child. Slanting winter sunlight can create atmosphere.

Pond life Smaller pond subjects, such as fish, tadpoles, frogs and toads, dragonflies and other insects are tricky to isolate from their surroundings. To get shots that cut through reflections, ideally you need a polarising filter, which at the same time reduces the amount of light reaching the film inside your camera. Most compacts do not automatically compensate for this loss of light, nor can they show you the precise effect of the filter before you take the shot. It is safer to stick to shooting subjects below the pond surface in a shaded section of the pond where there are no reflections to obscure the view.

Stick to Macro mode if you find frogs and toads sitting by the pond to photograph. If they're mating, you may get quite close without disturbing them!

Moving subjects, such as dragonflies and waterboatman, may need flash; if they come out too small, you can enlarge them, provided the negative is pin-sharp.

Tree-top subjects A bag of bread or peanuts can be used to lure squirrels down from their lofty heights in the trees. Gray squirrels are more used to feeding on the ground than red squirrels, and indeed are far more common.

Once you've got the squirrel within range, time the shot so it is sitting up on its hunkers eating a nut. Behavioral pictures like this are far more exciting than simple, grabbed portraits.

Most squirrels are particularly tame in early spring as their autumn food stores are almost expended. You will therefore have the creature's attention for a much longer period than usual.

LEFT *Because they're distracted, mating frogs are quite easy to photograph. Shoot with your camera on macro mode.*

BELOW *An overhanging tree creates sufficient shade to see below the surface of a shallow pond.*

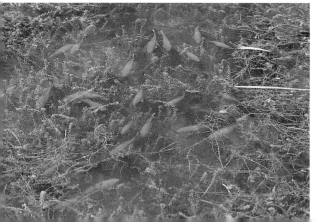

Trouble Shooter

Q How can I get pictures of wildfowl taking off and landing?

A Often the first you know about a swan or duck landing is the colossal splash of water just behind you! An excellent photo-opportunity that's easily missed. The answer is to be prepared:

• Watch the sky and get ready when you see one flying low
• Adopt a side-on viewpoint
• Smoothly train the lens on the bird as it makes its descent — a technique known as "panning"
• As the bird hits the water, gently squeeze the shutter button without jerking the camera. The result should be a sharp shot of the bird, frozen wings outstretched behind it, isolated by a slightly blurred background.

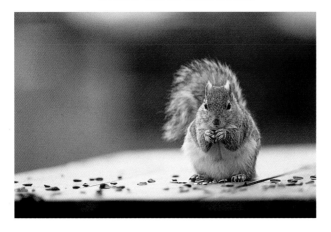

Take great care over the lighting and backdrop:
• Lure the squirrel into woodland shade so you can use a blip of fill-in flash without relying on overhead sunshine which creates shadows and washes out subtle nuances of color. Flash also injects small highlights in the eyes which makes them look more lively.

ABOVE *The classic squirrel pose – eating nuts.*

BELOW *Humans lead the eye to the subject despite the distracting pigeons.*

• Compose the shot so it has a distant, neutral background (like tree bark or foliage) against which the subject will stand out better. The lens' telezoom setting throws out of focus any distractions beyond depth of field, provided there are no people or brightly colored bins in the background.

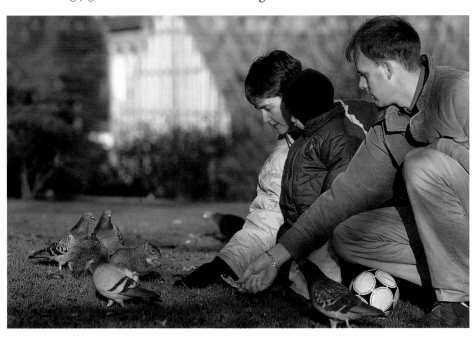

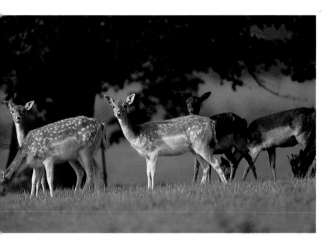

LEFT *Parks make photographing deer much easier than tackling them in the wild. Click your fingers to get their attention.*

Camera Skills

■ When you spot a subject, do not hurry your picture-taking as you may frighten the animal away before getting the best shot. Extend the zoom to its maximum setting before you approach (to cut down noise closer), then lure it with suitable bait, checking your viewfinder occasionally to see how large it is in frame.

■ Time your pictures to show interesting aspects of animal behavior, but don't sacrifice composition for the sake of it. For instance, try to show a group of ducks diving for food with their bottoms aloft, while cropping the composition tightly on the group. Start off with three birds in frame and wait for a triangular pattern.

Deer parks Deer are sociable creatures, preferring to live in herds, like cattle. They come into the open at dawn to feed on leaves, grass, berries, shoots, ferns, root crops and cereals. If you go on a nature reserve to photograph them, take some food for them with you but ask the warden, who might assist in setting up a shot for you, for permission to feed them first.

Though calves are born from early May to mid-June, autumn is possibly the best time for deer pictures, when males lock antlers during the rutting season. Many species make a din at this time, but do not get too close to their battles lest they mistake you for a rutting male!

Instead, compose a picture of the group from a distance, making use of seasonal foliage and attractive low-angled lighting for best effect. If it is misty, you may get some striking high-impact images of silhouetted stags rearing up from the gloom.

Stalking is another way to get a larger image of a deer or other large animal in the park or nature reserve (as discussed in the chapter on fieldcraft). You may find the real problem is other visitors less sensitive to the deer than you are. This is a good reason to visit early or late in the day or outside the main tourist season.

Into The Woods

The deceptive stillness of a wood or forest conceals thousands of animals, from aphids to owls, badgers to blackbirds, rabbits to moles and woodmice. In fact, a larger variety of creatures choose woodland as habitat than any other type of terrain, each animal involved in a complex web of predatory behavior and with a wealth of different types of shelter, too.

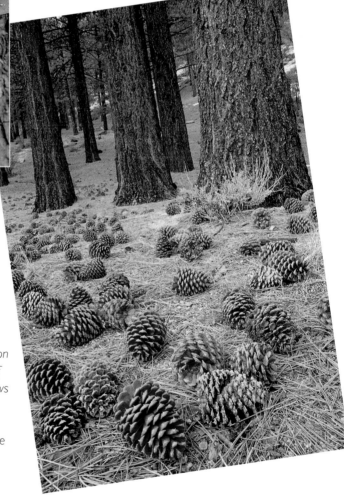

ABOVE *Fungi usually grow in dark, damp places, so use flash or a reflector board to help light them.*

RIGHT *Put the camera on a low tripod. This forest of ponderosa pine trees shows the typical clear spacious nature of the pine forest floor. Mixed woodlands are more cluttered.*

The forest floor One of the commonest mistakes people make when they take up photography is failing to shift their gaze above or below eye-level.

If you look down at your feet in woodlands, you find a host of things to photograph – unusual outcrops of fungi, fallen fir cones, acorn shells and decaying leaves, cobwebs suspended from plants, strange, gnarled tree-roots and a myriad other natural patterns, shapes and textures. Either shoot them there or pick them up and take them home – bearing in mind that unusual plants may well be on an endangered species list, making it illegal to uproot them.

Do's & Don'ts

■ Do wait for a misty autumn morning to photograph valley woods as brooding shapes shrouded in mist.

■ Don't disturb nesting birds.

■ Do photograph tree bark, filling the frame with its texture and using low-angled sunlight to skim across its surface, revealing peaks and troughs in the bark as shadows and highlights. Don't use flash as this will flatten out the composition.

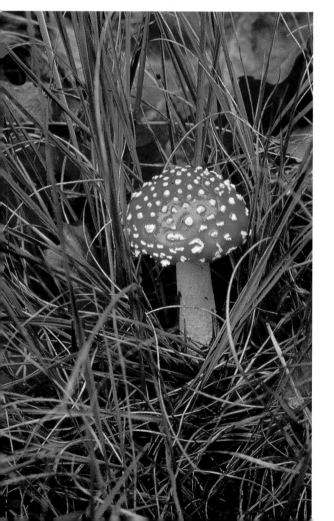

LEFT *Watch out for small subjects like this colorful but poisonous fly agaric mushroom.*

Camera Skills

■ As woods are dark places, you will find that your camera uses automatic flash to avoid camera shake. Use a gold or silver reflector to boost light or switch to a faster film speed.

BELOW Careful research can reveal a fox's den, though you'll need a blind for a shot like this.

Fungi grow only in damp, wet, dark locations – hardly the best conditions for photography! If a mushroom is growing close to the ground (such as fly agaric) or off a low tree-stump, use a low, mini or tabletop-tripod and set the camera to fill-in flash mode to boost light levels. Also use a cable release and adapter to avoid camera shake.

Watch out for parallax error (see *Jargonbuster*), especially with tall fungi such as stinkhorn – it is tempting to glance only briefly into the viewfinder when the camera is low down, but it really pays to prostrate yourself on the ground (protecting your clothes with a plastic sheet or waterproof jacket). Lying down also shows if the composition is aligned with the ground and that the background is not too confusing.

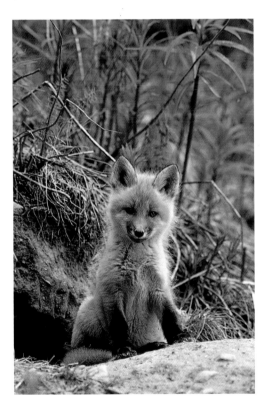

Mammals It is rare that you stumble across a vixen (female fox) with her cubs in broad daylight but, if you research your local woods well, you get an idea of where to find her den or earth, usually in a quiet spot in a hollow under a tree. Some make their homes in an enlarged rabbit warren or in part of a badger's sett, and the den itself will be musty, untidy with food and excrement.

Foxes are incredibly sensitive to smell, making them very difficult to approach other than up-wind. They have their young (three to six cubs) in April, and the vixen teaches them to hunt and defend themselves about one month later. Because foxes hunt mostly at night, you are unlikely to see one in daylight unless you are very patient and use a blind or hide (see page 48).

Rabbits are far easier to spot, though they are perhaps a more familiar sight in the meadows linking isolated woods than in dense woodland. They can be seen grazing on grass or feeding on other plant material, their ears pricked up, ready to retreat to their burros at any disturbance.

Badgers are a third, highly photogenic, woodland mammal, best tackled at night using the techniques outlined in the chapter on the night shift (see page 42). Look out for their burrows, called "setts," bordering pasture land, with a scratching post outside, a strong territorial scent and dungpits. Though wary, badgers have no enemies apart from man and can be baited using earthworms, mice, sardines, voles, frogs, snails, blackberries and windfall apples.

Woodland birds One of the best ways to photograph birds is to set up a hide or blind, camouflaged from human attention and timid birds with dark-colored fabrics, foliage and bracken. Ground-level blinds or hides are ideal for ground-level birds such as warblers and wrens and for shrub-perching birds like robins and blackbirds.

Picture Pointers

■ Camera height and angle are important for shooting woods. If you stand close to a tree and tilt the camera up so the branches tower over you, the tree seems more impressive. Or if you stand at a distance from a wood, perhaps looking down on it from a hill, the trees seem diminished. Think about the effect you want to achieve before taking the picture.

BELOW *A hide built on a wooden platform, helps you get close to climbing birds like this woodpecker.*

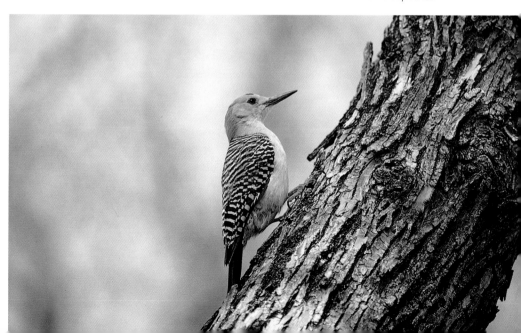

Trouble Shooter

Q What's the best way to photograph tall, thin trees such as fir and pine?

A The main problem is that, standing on their, own such trees occupy only a sliver of the image. In woodlands, it is hard to get far enough back to get the whole tree in without tilting the camera upwards and getting "converging verticals" (where the tree seems about to topple over backwards).

The answer is to compromise: either stand well back and shoot the trees together, filling the frame with their green boughs, or shoot from below and exaggerate the distortion using the wide-angle end of your zoom. Experiment with different distances and camera heights for an appealing picture.

RIGHT *Fill the picture area with colourful tree top foliage viewed from a nearby hill.*

Climbing birds (woodpeckers, nuthatches and flickers) may require a slightly higher blind or hide, built on a platform, while tree-canopy birds (like tits, finches and predators such as owls) will demand more elaborate tactics, using bait to lure them down to the ground or lower branches.

Once the bird is within your field of view, make sure its pose is worthy of a photograph: small birds move around more quickly than larger birds and it is easy to miss the best pose through poor timing.

Trees and shrubs A wood or forest is made up of many types of trees. The best are a mixture of broad-leaved trees which provide the most diverse habitats for animals.

However, plantations of pine trees, grown primarily for their timber, are widespread as well, and, though such habitat is home to many species, including small mammals, there is less wildlife here than in other, mixed-deciduous woodlands.

One of the most exciting things about photographing trees is the way they embody seasonal changes, with dense summer foliage, autumnal color changes, winter's skeleton of branches, spring blossom and late-summer fruits.

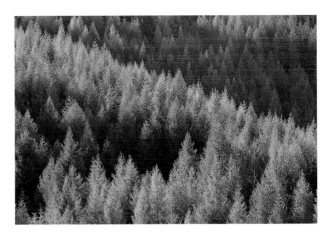

Try to catch these radical changes on film by photographing the same tree across a single year, on the same type of film from the same position and with the same focal length. You can mount and frame them together to illustrate a home-made calendar or as a Christmas gift.

LEFT *Watch the woods throughout the year for pictures showing the radical changes wrought by weather and climate.*

BELOW *Misty conditions in autumn and winter are excellent for atmospheric pictures where sunlight slants through the trees. Use a tripod and slow ISO 50 film for best results.*

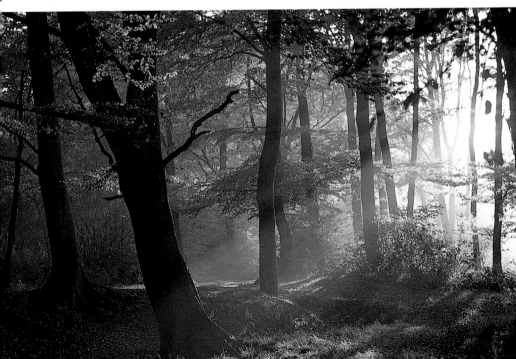

The Night Shift

BELOW RIGHT *Working at night requires careful preparation so you know in advance where to find your subject., like this owl.*

Photographing wildlife outdoors always exposes you to one major hazard: the weather! There is only one way round the vagaries of light in different climates and seasons, and that is to work at night. Using a compact camera to capture nocturnal creatures' activities is quite a challenge: you need dogged determination and lots of warm clothes!

BELOW *Chance encounters with animals like this toad do happen, but you won't see them if you stay indoors or in your car at night.*

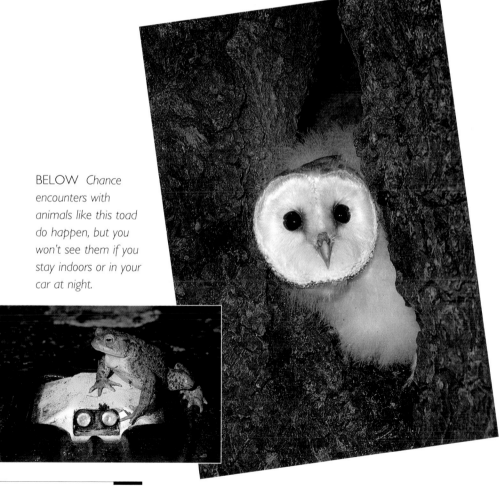

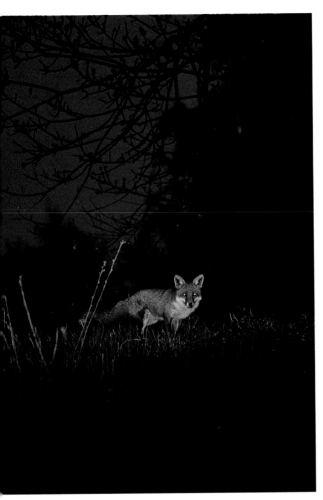

LEFT *Invest in a couple of additional flash guns which can be rigged up to your camera and then triggered by remote control when the subject crosses an infrared beam.*

Picture Pointers

■ As you cannot see through the camera's viewfinder, there's little point in sitting directly behind it. Use a long cable release (and, if your camera has no cable-release socket, a cable-release adapter), to trigger the shutter. Remember nocturnal animals have excellent night vision and can see you perching near the bait.

■ Leave plenty of time before the subject arrives at the bait to accustom your eyes to the dark. Do not use a flashlight after dusk if possible.

■ Wait until you can hear the subjects eating the bait before making the flash exposure. They may be startled and leave.

Photographing at night is not quite such a crazy idea as you might think: it is like an outdoor studio where you control the light with flash and there is also the excitement of working in an eerie, alien land of strange noises, hooting owls and cracking branches. It is not for the fainthearted, so maybe you should take a quiet friend along.

The main problems of the dark are moving round and finding and focusing on your subject.

Camera Skills

■ Ask your camera shop for fast ISO 800-1600 speed film for night photography. Though this may be rated at ISO 800, you can "uprate" or "push" the film up to ISO 1600 for added sensitivity. However, it is essential that you first check that the camera allows you to set ISO speeds manually. If the camera has an ISO button, set this to your desired speed (in this instance 1600) and then load the film. Take the film to a professional lab for processing and tell them you have uprated it one stop, to ISO 1600. These films seldom have DX coding bars on the cassette, hence the need to set the speed manually.

FAR RIGHT Creatures at night are mostly looking for food and travel the same tracks in search of it. Bait them with something special like milk, dog food or peanut butter.

Locating the subject Certain creatures can be stalked at night: mating natterjack toads will be far too busy to notice you and your camera and badgers are also generally tolerant of a someone with a flashlight.

However, even in broad daylight you wouldn't expect to stumble across an animal while walking in the woods. So, you need to do some preliminary research and reconnaissance first. This way, you amass plenty of useful facts.
• Owls hunt for mice and other small mammals at night, roosting in empty barns and tall trees.
• Bats like deserted outbuildings and can often be found hanging upside down from walls and rafters.
• Badgers may arrange their bedding outside the sett.
• Mice leave nuts gnawed idiosyncratically.
Fortunately, with nocturnal animals you can do lots of sleuthing during the day.

Positioning the subject Having found your subject's usual route, feeding site or home, set up your picture using bait, such as sardines or peanut butter for badgers. Ask yourself the following questions:
• Which direction will it come from?
• What will its stance be as it arrives?
• How close can I position the camera before accidentally cropping its head?
• Where should I focus? (Remember that depth of field may be limited, but it is fairly safe to focus on the bait. Use a small soft toy as a dummy subject to practice with the focusing and framing spot.)

Flash tactics For really attractive results, you need to invest in a couple of additional flashguns and a flashmeter. However, given the expense, you might want to try a small but very handy alternative – an accessory called a "slave flash" which is about the size of a deck of cards and is relatively inexpensive.

The slave is an independent flash unit which senses

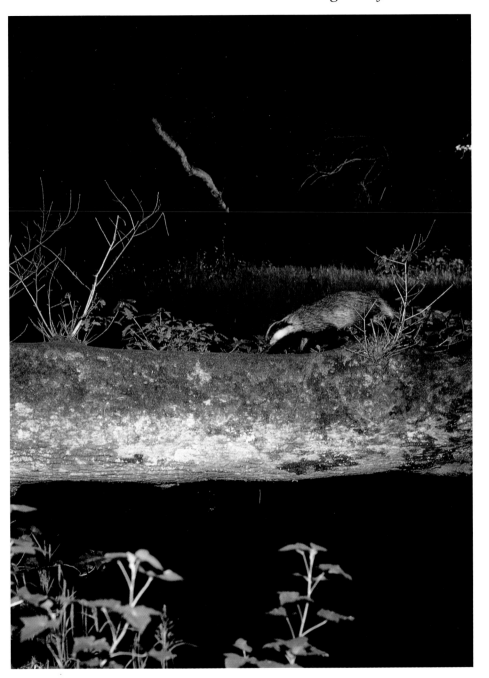

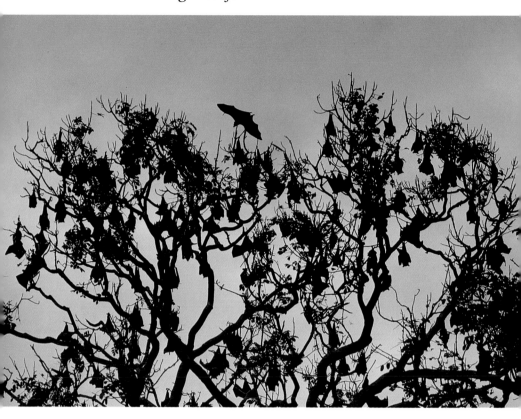

Do's & Don'ts

■ Do listen for night calls and other wildlife noises. Get used to identifying them and where they're coming from.

■ Don't give up after one failed session. Good pictures require patience and determination, especially at night.

the light from your camera's flash and responds to it. Thus, when the subject strolls into the area and takes the bait, you can trigger your own camera's shutter and built-in flash, which will in turn trigger all the slave flash units simultaneously.

Set up the units at dusk and test the distance required by the slave flash units to avoid over- or underexposure. You can use more than one slave flash but avoid them pointing back at your camera, or you could silhouetté the subject and may encounter unwanted flare.

A good set-up would be to have your camera on a tripod between two slave units, each at roughly 45° to the camera, all pointing at the bait.

Using fast film If you wish to avoid flash at night (and many photographers understandably prefer to work without upsetting the subject with bright lights), fast colour and black-and-white film present another option. The resulting images are grainier and the films demand lighter conditions – for example, at dusk or under a full moon in the open when there is some ambient light in the sky. If, for example, racoons visit your back yard at dusk and don't mind room lights on or a garden security light, these are ideal conditions in which to use a fast film, especially with the camera supported on a tripod.

LEFT At dusk when there's still some light in the sky you can isolate silhouetted fruit bats as they come in to roost.

BELOW Some nocturnal visitors, such as these racoons, are happy to come within range of your house or headlights looking for scraps.

Trouble Shooter

Q How can I pre-focus the camera in the dark?

A In low light, many autofocus compact cameras use an infra-red autofocusing system. Alternatives involve sending out a small red beam of light to locate the subject and assess focus and flash-to-subject distance.

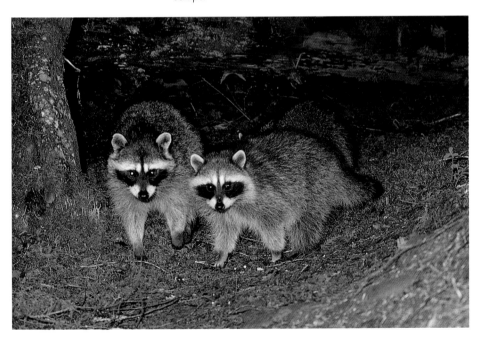

Using a Blind

Picture Pointers

■ Many animals feed at dawn, often the best time for using a blind or hide, but you need a fairly fast, more light-sensitive film than usual, such as ISO 200 or ISO 400 so you can use a tripod instead of flash.

■ Wait for the subject to stay still, looking at the camera or off to one side in profile, before taking the shot. You may get only one chance if your camera is noisy; if the animal moves, your picture will be blurred unless it is very bright and sunny.

RIGHT *If you set up your blind by on a river bank, you may be surprised what results you get.*

Getting close to wild animals needs some camouflage. With tame, young and docile creatures, this can be as rudimentary as wearing neutral colours to keep a low profile, but with timid species it may involve the option of using a blind, or hide. This offers three advantages: it allows you to get close; it can be permanent so if you do not succeed at first, you can try again; and you can site it almost anywhere – taking the blind to the subject, rather than waiting for it to come to you.

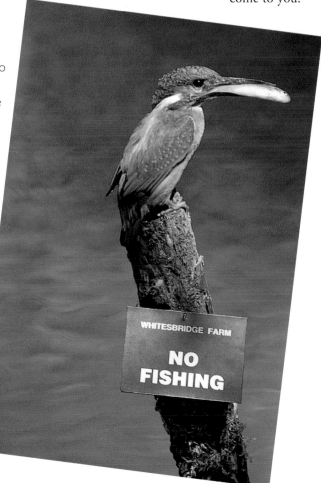

WHITESBRIDGE FARM

NO FISHING

Wildlife preserves There are lots of different types of hide. At wild bird reserves, the hides are often permanent and at some distance to the subject – perhaps overlooking a reservoir, marshland or the nest of a rare bird species.

The main problem with such blinds is that they are at such a distance from the subject that it can be exceptionally difficult to get a decent-sized magnification, especially with a fixed-lens compact camera. There is only one way to get round this: by taking your photographs on a slow film (like ISO 50) then having the print selectively enlarged. Slow films have a finer grain, so detail is clearer when enlarged than with ISO 200 or 400 speed films.

Amphibious blinds Some photographers prefer to get right down into the water with wildfowl, gaining a novel, low-angled perspective by using a "floating blind." They are relatively inexpensive, and look like a cross between a plywood raft and a tent! You need to take your

Trouble Shooter

Q How long will I have to wait before seeing any wildlife from my blind?

A This depends on how well you have researched your subject. Position the blind or hide somewhere that you know is frequented by your subject. Reconnaissance pays off in many places:
• River mouths (where coastal estuaries meet freshwater streams).
• Abandoned farm outbuildings (ideal for bats and owls).
• Sheltered river banks with no pollution, away from tourist attractions.
• Large deciduous woods and ancient natural forests with mixed tree growth.

ABOVE and LEFT
Wildlife reserves and nature conservation centres often have public blinds or hides, for viewing rare species nesting and pictures of larger flocks roosting on reservoirs and estuaries.

RIGHT *Portable canvas hides are great for garden photography beside a bird table when there's no breeze – otherwise the canvas will flap and startle your subject. This problem is solved using a plywood hide or outhouse, though it's less portable and requires more camouflage if used in a public area.*

Do's & Don'ts

■ Do avoid showing cars in the background if you use your car as a hide. Bait an area close to the car so your subject comes near to you.

■ Don't disturb parent birds at the nest.

■ Don't start taking pictures from a blind at breeding time - practice setting it up during winter or late summer instead.

■ Do ensure your blind is as well hidden from humans as it is from animals or it may get vandalised or stolen!

time manoeuvring the hide into position, using paddles and the tides to help float you in among your subjects to within six or seven yards. Amazingly, flighty birds such as the curlew and oystercatcher are unruffled by a floating blind, perhaps assuming it to be an abandoned boat.

The main disadvantages of the amphibious hide lies in their lack of comfort, the need for warm, waterproof clothing and the potential dangers involved in tidal areas. Avoid getting out of your depth and do not get stuck in the mud!

Making your own There are two types of land blind or hide you can make: one uses local materials (e.g., reeds and branches on the water margins); the other employs canvas or plywood for a more solid structure. The one which looks like its surroundings enables you to get much closer to your subject than that which looks like a man-made object. However, it is possible to use local camouflage (branches and foliage) on canvas and wooden hides.

First, you need to find your wildlife using the planning and fieldcraft techniques outlined in previous chapters, then plan where to lure your quarry, to a clearing in a wood or field where the light is good. Next, decide which type of blind or hide to build. If you are a novice, it may be a good idea to settle for a canvas hide on poles: you can make your own using a

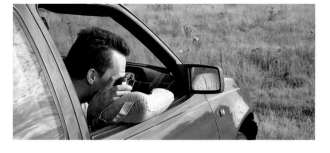

large sheet of green and brown tarpaulin (from army surplus suppliers) and tent poles which can be wedged into the earth. You may like something less draughty: a ¼inch plywood hide can be made to any size (perhaps a rectangular cube measuring 3 x 4 x 3 feet), with struts for rigidity and angle brackets for the corners. Use a waterproof oil-based paint to camouflage the sides brown and green and make a hinged door.

Finally, put the blind in place. For best results (depending on the subject and how prone it is to fleeing), bring it to the spot in stages over a couple of weeks. Otherwise, erect it at a distance and move it closer gradually, over days rather than hours. The subject needs to become accustomed to it. Once the blind is finally in place, go into it with a friend who then walks away. Many creatures have trouble counting and think that when your friend has gone, so have you!

Using your car Strangely, creatures which feed close to roads like rabbits, pheasant and deer are less worried by a car than by a human being. Kestrels hover above highways, while crows and magpies feed on road casualties. Seagulls, crows and finches can be lured closer to your camera with scraps of bread if you park beside the road or in a car park. Just drive to a likely spot on a track or up a mountain pass, switch off the engine and open the car window.

As it is impossible to use a tripod inside the car, you might find it easier to make a small plywood ledge to hang over the lip of the car's open window, with a beanbag resting on top to wedge the camera. Putting camouflage netting over the window can conceal your face and hands.

ABOVE *Even your car can be used in locations where animals are used to traffic, but wary of humans.*

Camera Skills

For best results, set the camera outside the blind on a tripod beside the bait, then trigger it by remote control. Some top-of-the-range compact zoom cameras offer an optional remote control handset for self-portraits which can be used for animal photography too.

Wait patiently until the subject comes into range but not too close to the lens; set the camera to macro mode then trigger the shutter. Make a note of the camera's closest focusing distance when setting up the bait.

Going On Safari

RIGHT *Safari buses and jeeps are the safest means of getting around. Ask the driver to get as close as possible.*

Photographing domestic wildlife can seem unexciting in comparison to going abroad on a photo-safari – if you're lucky enough to be able to afford it. Not only are African and Indian nature reserves larger than the home-grown variety of wildlife sanctuaries, but the species to be seen there are bigger, more colorful, and often far more ferocious!

BELOW *As vast buffalo herds migrate across Africa's Masai Mara, a host of predators follow, making this an ideal opportunity for photography.*

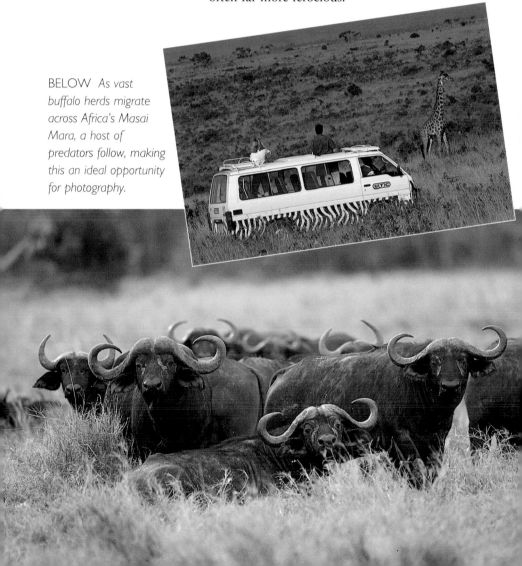

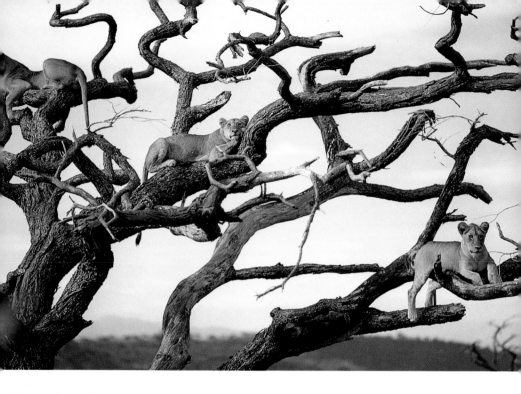

Planning Shop around for bargain flights, but make sure you invest in a good tour operator or agency which will get decent accommodation and help you make all the necessary arrangements including a local guide, reliable jeep and driver.

Next, research your chosen destination thoroughly: the wildlife to be found there, its typical watering holes, seasonal habits, feeding and breeding practices.

Most important: before you book, make sure you check the weather and find out when the rainy season will be (Kenya's, for instance, is in April). Though it is often cheaper in the wet season, long grasses often make it difficult to see wildlife and the jeep might get bogged down in the mud.

Shooting big game Sadly, the short focal length of most compact-camera zoom lenses is a severe limitation on safari. It is worth taking along a fully automatic SLR and long autofocus lens (at least 300mm).

ABOVE *It's worth investing in or borrowing a fully automatic program SLR for your trip – chances are your compact's zoom lens will not be long enough for studies like this.*

Picture Pointers

■ To avoid getting a whole set of similar pictures, try turning the camera through 90°. Sometimes, such subjects as trees or giraffes look better in a vertical composition.

Do's & Don'ts

■ Do ask your driver to wait at watering holes and other places frequented by wildlife. If you watch and wait, you may see a perfect composition!

■ Do try to get pictures which show typical behavior. For instance, rather than a boring grab-shot, compose one of a lioness with her cubs or feeding on a recent kill.

Camera Skills

■ To avoid camera shake, wait until the jeep has stopped and the engine is off. In very bright sun, you may get away with it should a photo opportunity occur while you're driving along. This is because, in bright light, the camera automatically selects a fast shutter speed, allowing you to freeze both camera and subject movement.

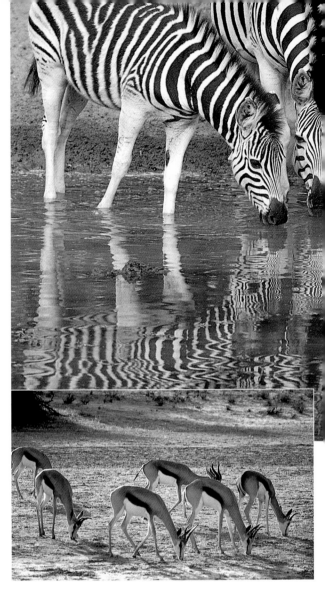

TOP *Watering holes are excellent places for wildlife pictures. Try to include the animals' reflections in your compositions – still water is best for detail and symmetry.*

ABOVE *These grazing springbocks form a neat and ordered composition as they're all facing the same way. Use exposure compensation to avoid silhouetting the subject in poorly lit conditions like this.*

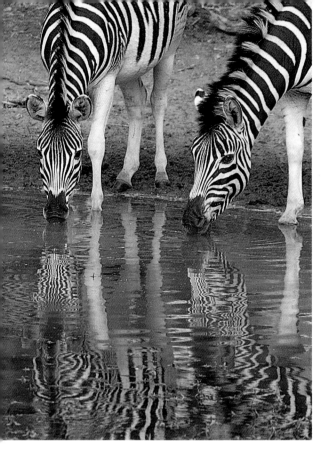

Many camera dealers hire them out for holidays for a deposit covering the camera's replacement cost.

If you'd rather stick with your own camera on the principle that you understand it better so there's less chance of getting a poor result, there are three things you can do to improve your chances of getting decent magnification:
• Use very slow film (like ISO 25) so you can selectively enlarge the print
• Ask the driver to get closer to the animals than usual
• Compose every shot to include the animals' habitat and the rest of the group. It is extremely unlikely that you will get full-frame portraits of individual animals, so make sure group shots are all carefully composed, with some of the animals looking up at the camera;

Trouble Shooter

Q Will the airport security x-rays damage my films?

A Only the very fast films (ISO 400 – 6400) are adversely affected by x-rays as they are more light-sensitive. However, if you travel from one destination to another via countries with antiquated machines which x-ray the films at every juncture, there is a small risk of compound film damage.

Some airport officials are very photographer friendly and will agree to search your films by hand. Keep your films to hand but in a lead-lined bag (specially made for photographers and inexpensive) where they can easily be searched.

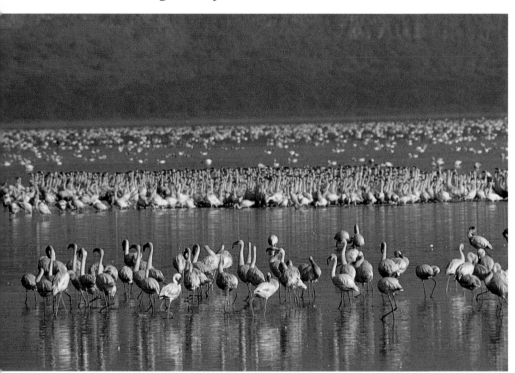

ABOVE *If you can't get close enough for full frame animal portraits, stand back to get the whole flock or herd in frame and try to concentrate on making patterns of color instead.*

avoid distracting subjects in the background to preclude such results as trees growing out of heads.

Color and pattern Concentrate on isolating color, texture, and pattern. For instance, fill the frame with a sea of pink flamingoes at a watering hole, or with the striped flanks of a herd of zebra. Do not just shoot as soon as you see an exciting subject, such as a pride of lions; take your time to compose a shot which shows how the subject fits its environment – for example, lions using the dappled shade of trees or sun-bleached grasses to stalk their prey.

Silhouettes at sunset The flamboyant skies at dusk in the Serengeti make a fabulous subject in their own right, but how much better that sunset will look

if you can find some form of foreground interest as a focal point to your composition. The outline of a gambolling giraffe, lone-tree scavenging birds or a bull elephant with his ears outstretched transform a good picture into a great picture.

To get the exposure right, slip the camera onto the tripod, switch off the flash and point the light-sensing meter at a patch of sky, avoiding the sun. If it is in frame, poised to slip below the horizon, it may be an idea to wait for the sun to get really low so the sky will not look washed out. Tackle a static silhouette after the sun has dropped below the horizon when the sky is most vivid but never attempt this without a tripod.

It is a good idea to experiment with a cable release to hold the shutter open on the "Bulb" or "B" setting, counting the exposure manually. Try counting to five and then ten – though, as there's no control over the aperture setting selected by the camera, this "time exposure" approach to the afterglow can really be quite hit and miss.

BELOW *Wait and watch the subject's behavior then time your picture to coincide with something interesting, like this hippo in the Okavango.*

BOTTOM *Silhouettes against a dusk sky are easy and very dramatic.*

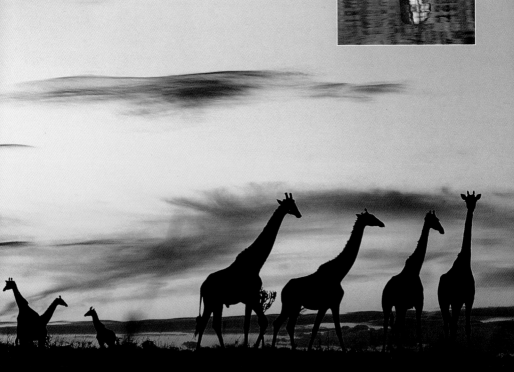

The Modern Zoo

Camera Skills

■ For dark "nocturnal" enclosures, use fast ISO 400 film rather than flash and use existing illumination to avoid an ugly, flat effect, where the flash falls off sharply at the edges of the image.

However, if you have a "night portrait" mode, slow sync flash or fill-in flash mode, use one of these instead. This flash mode automatically adjusts the flash output to augment the available light.

Zoos have a convoluted history. Once they were grim places with the animals displayed as amusements to a public with little respect for wildlife. These days, though, you will not find elephant rides, chimpanzee tea parties or bear pits. The emphasis is on breeding programmes and conservation of rare species. There is still a long way to make zoos more hospitable to their

RIGHT *Find a covered backdrop which can be thrown into shadow as with this sunbathing lemur.*

BELOW *Wildlife parks are the best place to see exotic animals. If you cannot open windows use the infinity focus mode so the autofocus doesn't lock on to the window instead.*

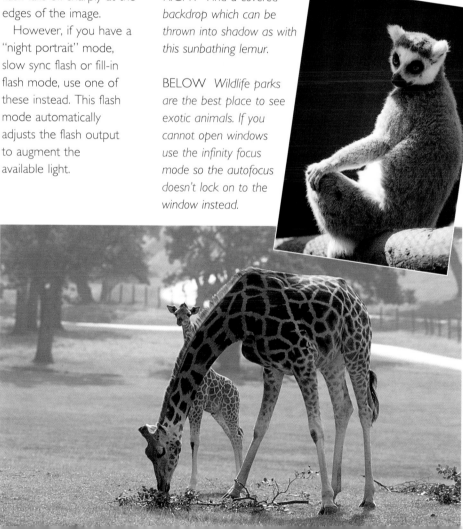

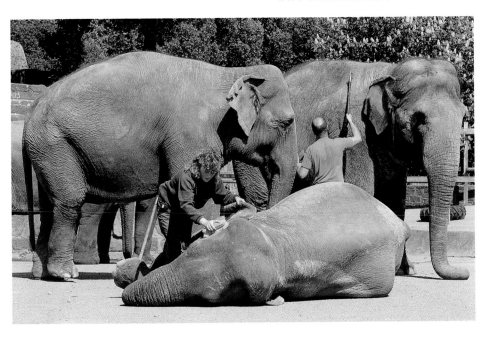

"inmates," but the modern zoo is certainly a good starting place at which to encounter nature.

Wildlife parks These are wonderful places where animals are free to roam in large enclosures, feeding and breeding in relative privacy. In fact, it is often the homo sapiens in their cars who seem to be the ones held captive!

The main problem with wildlife parks is that you cannot always see the animals in the enclosure. Either wait around for a while until the animal becomes used to you or curious about you or wait until feeding time: the creatures quickly become more visible and active when they are about to be fed.

Beating the enclosures At conventional zoos, it can be hard to avoid the glass or wire enclosing the animals. If the wire is fine, you can put the lens right up to it so the wire does not appear sharp in the frame.

ABOVE *Feeding and cleaning times lead to exciting behavior photos.*

Do's & Don'ts

■ Do get a map of the zoo so you can get around quickly from one enclosure to another, marking those you want to visit at a particular time

■ Do use your car as a blind at wildlife parks with drive-in enclosures. Don't open the window if there is any danger

RIGHT *This emerald tree boa was photographed through glass but the photographer was careful to put the lens and flash right against the window to avoid flare.*

RIGHT *Wire enclosures are avoided if you put the camera so close to the mesh that it falls outside the zone of sharp focus. With wider mesh you can poke the lens through it.*

Trouble Shooter

Q How can I make zoo buildings look less intrusive?

A When you select the telephoto end of your zoom, the camera automatically sets a wider aperture and shallower depth of field (see *Jargonbuster*). This means that buildings behind subject are softer and out of focus. Hunt around for a better angle – perhaps a low one so you can see a patch of sky behind the subject in the viewfinder.

With glass enclosures, find a clean patch (take along some of your own lens cleaner, just in case, for a spot of window washing) and, again, put the lens right up against the glass. This avoids flare from the flash reflecting off the glass.

Look for outdoor subjects where you can zoom in for a frame-filling portrait that avoids ugly bars, ditches, fences, wires, and other zoo visitors.

Timing your visit Some zoos announce their daily feeding and grooming times. Often the keepers begin their feeding rounds at lunchtime.

These times are perfect for animated pictures – penguins and seals competing for fish scraps, elephants being hosed down and gorillas with their young tucking into fruit. Use the zoom to isolate animals and be careful not to get a muddled composition

Picture Pointers

■ Get to the zoo early to avoid the crowds. Before feeding time, use a tripod to stake your claim to a ringside position.

LEFT *This sea aquarium in Miami is great for getting close to killer whales.*

BELOW *Feeding time for a walrus and a sealion. Try to find a view with a naturalistic background.*

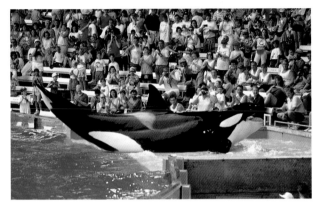

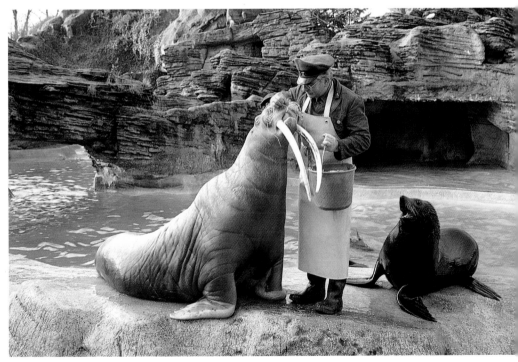

Going Underwater

There are three main problems with underwater photography: water destroys cameras; water refracts light, making framing difficult; and it is dark underwater in some parts of the world, so brilliant undersea colors need flash. Solve these problems and you have access to a fascinating and photogenic "alien" landscape with a myriad of colorful fish and plants.

Keeping the camera safe and dry

You can keep water out of your camera in one of two ways.

- Put your compact camera inside a specially-made watertight housing.
- Invest in a waterproof camera.

When looking for an under water camera, distinguish between those which are merely "splashproof" or "weatherproof" (like the Pentax Zoom 90WR) and those which are fully waterproof to a given depth (like the Konica Mermaid and Canon Sureshot A1).

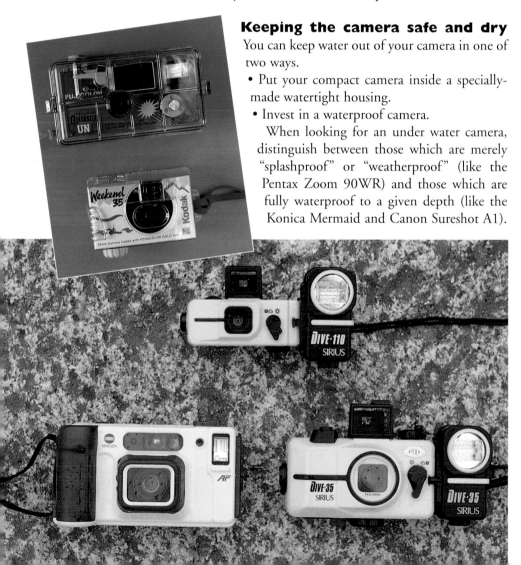

Often the difference between these cameras is obvious. Underwater cameras tend to be brightly colored (yellow or pink) with rubberized bodies and large, chunky dials, making them easier to use underwater.

Look for one designed for the depths you need – for instance, the Canon Sureshot A1 goes down to five meters, perfect for snorkelling and rockpools or streams – and one which offers a range of flash modes, such as Auto and Off (some offer red-eye reduction too). Some other useful features are Autorewind, a large viewfinder, Macro mode (sometimes indicated by a fish icon) and an autofocus lens (many models offer only fixed focus).

If you are not sure how often you will use an underwater camera for nature pictures, it is sensible to buy a single-use underwater camera such as the inexpensive Fuji Underwater Quicksnap or Quicksnap Marine, ideal for pictures of fish and crabs.

Housings When buying a housing for your existing camera look for one which is totally watertight. Load new film and fresh batteries before you dive so you have plenty of exposures and the flash does not fail. Also check the manufacturer's recommended diving depth. Above all, make sure the housing is sealed before taking the plunge.

Trouble Shooter

Q I'd like to invest in a waterproof camera. Are there any cheap disposable models?

A There are several single-use (disposable) underwater compacts: Concord's Le Tuff; Fuji's Underwater Quicksnap or Quicksnap Marine; Konica's Film-In Waterproof; and Kodak's Fun Waterproof – all relatively inexpensive. Check the packaging to see how deep the camera will allow you to dive. They are often safe up to 9 feet and are best used in bright conditions as they do not have a flash.

LEFT *A more expensive option is to invest in an underwater compact. A good idea if you enjoy snorkelling.*

RIGHT *You can always take your own compact underwater, provided it is safely packed inside a watertight camera housing.*

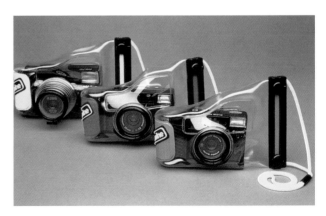

Going Underwater

FAR RIGHT *Certain oceans are clearer than others. Stick to the shallows for maximum available light and color.*

Diving pictures Rocky shores are often better than sandy beaches for diving pictures, as crabs, lobsters, starfish, sea urchins, and other creatures found there are unable to burrow into the sand. The number of underwater species you photograph depends entirely on how deep you can dive before water pressure damages your camera. Swaying fronds of seaweed also make a fascinating photo-essay: look for both common weeds such as kelp and bladder wrack and the more unusual varieties too.

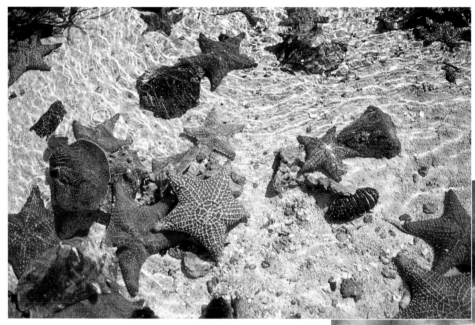

ABOVE *Starfish half buried in the sand make for interesting photographs. Try not to disturb the sand as this makes the water cloudy.*

RIGHT *Mind your toes! To provide a sense of scale for your underwater subject, why not keep something human in the composition.*

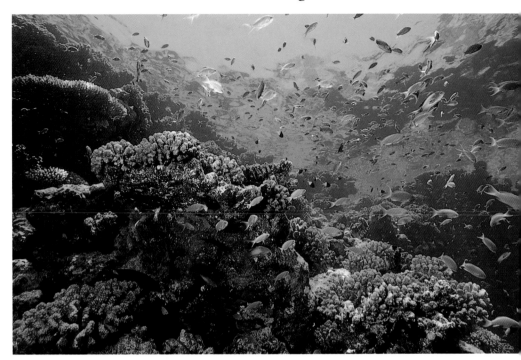

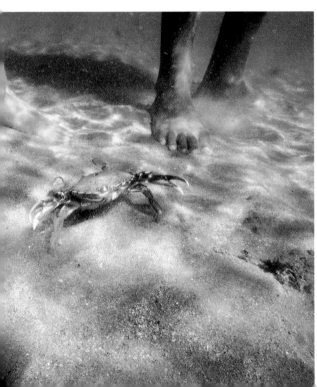

Camera Skills

■ Load ISO 200 slide film for a stunning sequence of underwater double exposures. Select ME (multiple exposure) mode and superimpose one image on another. This looks particularly good when you frame the shot to combine a colourful fish with a dark area of the previous composition.

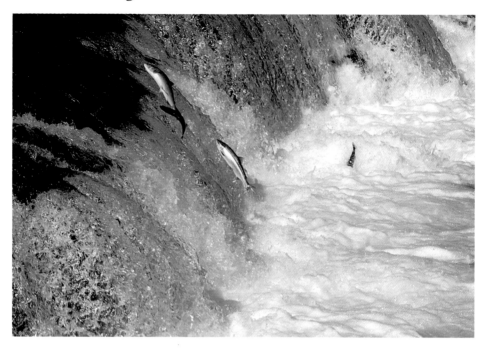

Picture Pointers

■ Note the parallax error markings in the viewfinder before pressing the shutter or your subject may be chopped in half.

■ To maximize depth of field (that which is in sharp focus) underwater, keep the subject parallel to the back of the camera. This ensures that fish facing you and close to the lens are in focus.

In marine reserves, you can see and photograph reefs and rock formations; it is worth contacting such underwater parks to find out about group diving expeditions, so you can scout the area for picture potential before taking the camera down.

Streams and rivers You do not have to travel to the Caribbean for pictures of fish. Some breeding pools and clean, freshwater streams teem with salmon, carp, pike, tench, trout and bream. In the spawning season, fish like the salmon and char sport brilliant courtship colors. Use a dinghy or waders to get into the stream, then dip the camera under the water to view the passing traffic.

Another approach would be to find an attractive spot near the bank of a clean stream, then lodge the camera on the bed, pre-focused and ready-loaded with film and batteries and weighted down with rocks. Fish

feed at the beginning and end of the day, so use these times to bait a spot in front of the lens (noting your minimum focusing distance, which may be as near as 18 inches) with such bait as maggots. Use a cable-release and adapter when you see the fish taking the bait. This takes patience, involving several attempts before you learn how to get an attractive composition without looking through the viewfinder.

LEFT *These leaping salmon have been caught while returning to their spawning grounds.*

BELOW *In the breeding season sockeye salmon display their courtship colors. For such shots wade out and wait for fish to come to you.*

BELOW *Though it looks a mess on the tidemark, seaweed looks beautiful swaying in the water.*

Do's & Don'ts

■ Don't use a conventional flash-gun underwater unless it is built in. If you need additional illumination, use a waterproof strobe unit or watertight rubber flashlight.

■ Don't dive alone with your camera, even if you are experienced at diving and snorkelling. Dive with a "buddy" who can help you look for suitable subjects.

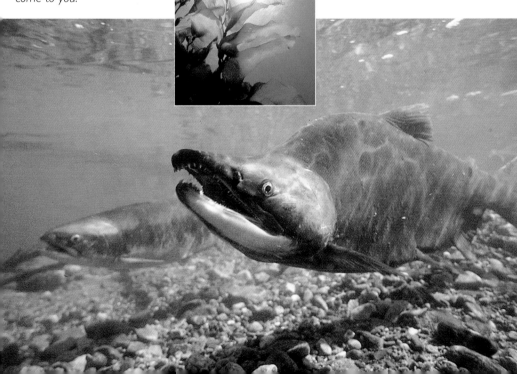

The Seasons: Spring

BELOW For calves, piglets and lambs in Spring pay a visit to a local farmer and explain your project to him. He may let you attend a birth if you promise to use a fast film, not flash.

Nature is governed by the four seasons. In spring, the glare of the sun reaches us through more haze. This period can be cold and fresh, though by late spring rainfall gets less frequent, soils dry out and dew evaporates; cold nights combine with warm, sunny days to herald summer.

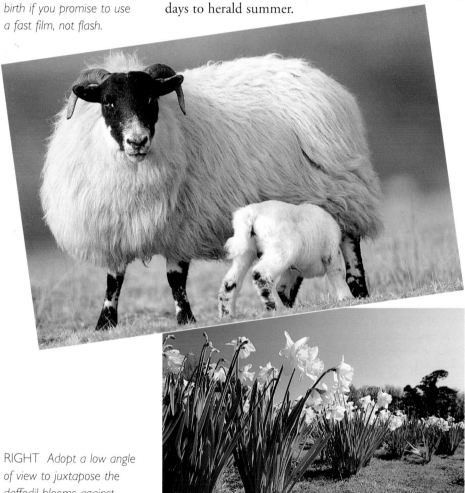

RIGHT Adopt a low angle of view to juxtapose the daffodil blooms against the sky.

Flowers Spring brings a host of colorful flowers to photograph, the main candidates being early crocuses, daffodils, tulips, and bluebells. Few sights are as glorious and heart-warming after a long winter as a carpet of wildflowers. As woods in spring are leafy, blocking out the sky and reducing the light, you need to tackle such a fabulous vista with a tripod and release the shutter with a cable-release accessory or self-timer. This is one instance where you can get away without a focal point. But also take pictures of one clump of flowers with the camera in macro mode, shooting from low down to avoid dwarfing the flowers and watching the parallax lines within the viewfinder.

Daffodils are another good subject in spring. If you have a zoom lens with autofocus, point the focus bars at a bloom within the frame to make it sharper than the others, acting as a focal point. Take a waterproof mat to lie on. This lets you contrast the yellow daffodil heads with the clear blue spring sky. If there is a breeze, use fill-in flash for the bobbing heads: a small amount of after-flash blur can look surprisingly effective.

Do's & Don'ts

■ Don't trespass on farm land: use footpaths shown on maps or ask if you can stand in tractor tracks for pictures of lambs frolicking at pasture.

■ Do keep gates closed and your dog on a lease.

BELOW *Bluebell woods – a classic springtime scene. Spend time wandering through the woods and use your viewfinder to access the potential of each new viewpoint.*

Picture Pointers

■ Get pictures of bees visiting blooms. This is more informative than a straight shot of a plant.

RIGHT *Focus on growth; buds, new leaves. Use macro mode but not so close your lens can't focus.*

BELOW *Use a table or mini tripod to support the camera and a reflector board to boost light for studies of crocuses.*

New growth You have to be quick to catch signs of new growth such as buds and shoots, but if you do, you can take a full sequence of pictures illustrating how plants have progressed during the year. Stick to

the same film speed, magnification, camera height and angle so that the pictures look identical save for the changing, growing subject. Make sure you anticipate growth by leaving a space around and above the bud or shoot so you will not end up cropping the image in later stages of growth. Keep checking progress at regular intervals.

Camera Skills

■ Flower petals look more color-saturated and attractive on film when light is diffused and flat rather than hard, bright and sunny. Shooting in shade or on an overcast day is one route to true color rendition. An alternative is to make a "light-tent" to slip over the top of the plant. Replace the old fabric of a large standard-lamp shade with plain white or cream diffusing-fabric such as muslin or a translucent shopping bag. Make a hole low in one side for your lens and a second hole opposite it so the background is shown without the edges of the light tent sneaking into view. Use it on sunny days to make the light softer, revealing more detail in the flower's recesses.

One spring subject is notable for its photographic potential: catkins, found on willow and birch trees. If you have a hazel tree or goat willow in the garden, clip off a small branch of catkins and bring them indoors in early January. Store the branch in the dark in a vase or bottle filled with water. Bring it out in early spring onto a window ledge (taking care not to knock or jog it) and prop a sheet of black card behind as a backdrop. Set the camera on a tripod and gently tap the branch to see the pollen disperse, simultaneously releasing the shutter by cable release.

The Seasons: Spring

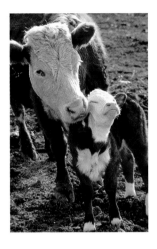

LEFT *When newborns are still attended by their mothers there are lots of opportunities to get intimate pictures like this. Stand close and crop the scene tightly – you don't need to keep the whole field in the picture.*

RIGHT *Pictures taken inside a covered barn will require either flash or the use of a tripod as light levels will be low. If you haven't a tripod and want to keep the atmospheric ambient light, why not try resting the camera on a beanbag or a haybale.*

BELOW *The farmyard is a rich source for nature studies and animal portraits. Ask the farmer to introduce you to the most characterful and photogenic creatures.*

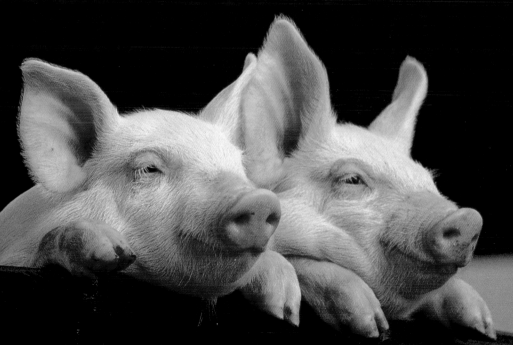

Trouble Shooter

Q How can I tackle cloud formations in spring?

A In spring and autumn the weather changes radically. This makes it ideal for cloud-watching: simply point the camera heavenwards, using perhaps only a thin sliver of horizon for detail.

•Cirrus is the highest cloud, formed of ice crystals.

• Altocumulus is the classic "mackerel" or "fleecy" sky with small, regular masses of cloud.

• Nimbostratus is low cloud with a ragged base, providing continuous rain.

• Stratus is a flat, gray, low sheet of cloud with occasional light rain.

• Cumulus is the fluffy, fair-weather cloud.

• Cumulonimbus is a towering thunder cloud.

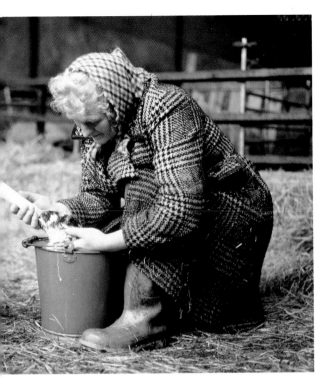

Farming year From the middle of February to the beginning of April, farmers start sowing crops such as corn, oats, wheat and vegetables. New grass is often sown in the same fields so that it grows right under the cereals and is ready for grazing after the harvest. From March, livestock are put out to pasture and the earliest grass, which is rich in protein, is saved for ewes, lambs and dairy cows.

For a photo project on the stages in the farming calendar, get friendly with local farmers and explain your intentions. They may let you into their fields and tell you when they expect crops. Dairy farmers may let you watch them in the milking shed, perhaps feeding calves and lambs by hand. Their abundance of knowledge and experience gives you a better idea of how to photograph their year.

The Seasons: Summer

Summer days are warmer and longer and abundant vegetation supports a great diversity of animals feeding on insects, buds, shoots, leaves, flowers, fruit, sap, wood, roots, dead plants (and on one another). A time of plenty, summer is favorable for young animals to appear.

Meadow flowers Throughout summer, flowers bloom and grow. In May, fields are full of eye-catching flowers, while poppies and day lilies adorn the roadsides and edges of corn fields from June to August.

For the best studies of flowers in fields, find a high place

LEFT *Another wildflower option is to tackle individual flower heads from close range, making sure that the light isn't so harsh that you can't make out the seed head details.*

Do's & Don'ts

■ Do attract butterflies to your garden by sowing plants that they love, such as nettles and buddleia.

■ Do grow your own sunflowers, lilies and poppies. It is far easier to get good flower pictures from your own garden! You could fake a meadow background by slipping an enlarged 12 x 16-inch matte photograph of a meadow behind the garden flower as a backdrop.

(perhaps an upstairs window if you overlook farmland) from which you see a pattern of green and colored fields rolling away to the horizon like a vast patchwork quilt. Crop tightly to fill the frame with a small section of this view, setting the flowering field off-center framed by green hedges and trees.

LEFT *A further approach is to lie down on the ground and point your camera up at the flower blooms so they are isolated against the sky above.*

Picture Pointers

■ Ask a sheep farmer when the flock is to be shorn. This can make for interesting action pictures of shearers and comparisons of "before and after" shots.

BELOW *Watch out for insects visiting flowers. This makes the subject seem more alive.*

There are a myriad of beautiful, colorful and delicate flowers at this time of year (like for instance, day lilies, tiger lilies, and poppies) which are usually very easy to photograph. Watch the background, though, for clutter and remember that you often get more impact focusing the composition around one bloom early in the day when the light is gentler and the color richer.

Experiment with different compositions using both extremes of your zoom: a close range wide-angle shot with the bloom sharply focused and a distant view of the field beyond has more " oomph" than a conventional portrait using the long end of the zoom.

Insects Summer is the best time for photographing butterflies in the hedgerow or bushes or on their larval-

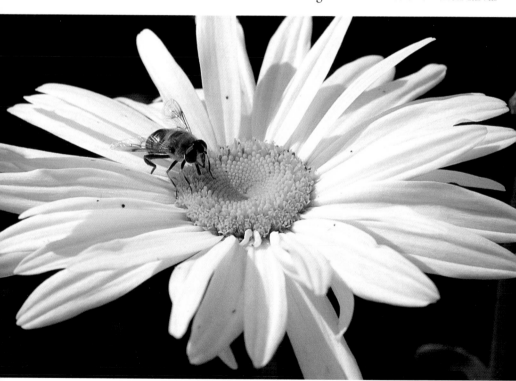

food plant. Look for plants which attract butterflies such as buddleia and stinging nettles.

There are many different types of butterfly. These include browns, yellows, whites, blues, hairstreaks, coppers, fritillaries, and vanessids (like the small tortoiseshell and white admiral). Each butterfly has a favorite food and habitat where their caterpillar food plants can be found.

Following a butterfly around with a camera is a very hit-and-miss approach to photographing it. Instead, track one down first thing in the morning while it is resting with its wings outstretched to dry the dew and absorb the heat necessary for flight. As butterflies cannot move until they have been warmed up by the sun, you will at least have a couple of minutes to line up the shot with the camera in Macro mode. An additional idea, perhaps, would be to add a touch of fill-in flash to boost the light.

ABOVE *Capture butterflies early in the morning: they sit still, wings open, warming up for flight.*

Camera Skills

■ Use a silver reflector or pocket mirror to boost flower colors in the field, bouncing daylight back onto the subject, which may be lit from the back or side. Try also slipping a diffusing filter in front of the lens for a romantic, soft-focus effect.

RIGHT *Fields of golden corn look fabulous in the sunshine.*

Trouble Shooter

Q I collected some shells on a recent summer vacation. How can I photograph them at home indoors?

A Buy a small bag or bucket of sand from a your local hardware store or garden center. Put a thin layer on a tray lined with a sheet of sandpaper. Place it on a table near a south-facing window to allow plenty of daylight to work with. Put the camera on a table-top tripod and angle the camera so it points straight down. Next, arrange the shells in the sand, keeping the composition simple for greater impact. Using an odd number of shells often looks better than an even number. Make the exposure with and without fill-in flash so you can compare the results.

Harvest time Farmers are busy throughout summer, harvesting grass for silage in May and for haymaking in June. Although the main harvest for cereal crops is late July onwards, August is the main harvest month in the south, and September in the north. Take pictures overlooking a farm from a neighboring hillside showing the progress of a combine harvester as it traverses the crop and cuts the corn, throwing out straw and chaff from the back. Position the vehicle in the image on one of the imaginary intersections of the "rule of thirds" (see *Jargonbuster*) for greater balance and impact, perhaps also using the field's tracks and ridges to lead the eye to the subject.

LEFT *With the farmer's permission, lie your camera in the corn and set to wide angle mode for a picture looking up to the sky taken with a self timer.*

BELOW *For an impressive composition, position the harvester so it forms a dynamic shape in the photograph.*

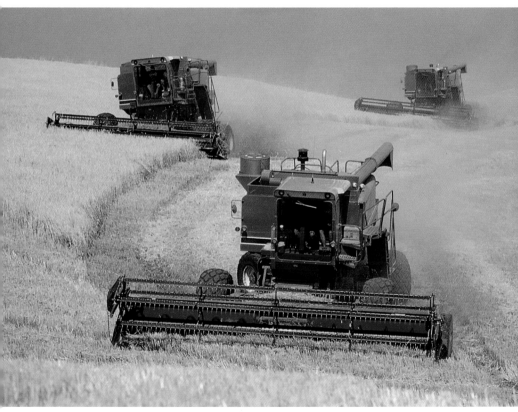

The Seasons: Autumn

BELOW *Point your camera straight down for a forest floor study. Use a tripod if the woods are dim.*

Autumn is a period of transition for the natural world. The sun's rays are weak; long spells of warm, calm weather are followed by stormy wet periods which saturates the soil. Mature foliage changes color and falls to the ground. The flowering season comes to an end but there is an abundance of fruits, the seeds of which take root and grow the next spring.

Fruits and foliage Flowering plants' swollen, succulent fruits are attractive to animals such as birds

Do's & Don'ts

■ Do visit an arboretum at this time of year to fill the frame with lots of different species of tree, homing in on the colorful foliage.

■ Don't forget to point your camera up and down, away from eye level. This will help you avoid getting the same old shots as everyone else.

and squirrels. Any woodland walk in early autumn (before the end of October) provides a fine opportunity to photograph berries which grow in shady hedgerows and bushes. To photograph them, select macro mode on the camera and if the light is slanting low, hard, and contrasty (making you squint), you may get better results by focusing on shaded clusters of berries, using either a fill-in flash or a gold reflector for shadow with subtler, less direct illumination.

Tree bark looks especially interesting at this time of year: use the slanting sunlight to skim the surface, highlighting the ridges and troughs to emphasize their tactile nature. There are many attractive trees to look out for at this time of year:

BELOW *To blur water in a waterfall use a tripod and no flash. On a bright day put a neutral density filter over the lens to block the light sensor so a slower shutter speed is selected.*

LEFT *The change in tree foliage colors is dramatic in autumn. Why not make a composition of the tree tops en masse by shooting them from a hillside.*

RIGHT *Side lighting is usually best for bark texture shots, but here the peeling bark of this silver birch is fascinating in its own right. Note how the framing of the two trunks makes them resemble knobbly knees.*

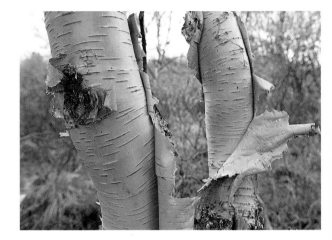

RIGHT *If a composition can't be found in the forest, collect the autumn fruits for a still life arrangement elsewhere. Then you can get the desired lighting.*

OPPOSITE *Lure squirrels with choice nuts and acorns. A profile composition looks best as depth of field can be maximised.*

Camera Skills

■ Use a mirror for inaccessible fungi. Avoid your own reflection by angling the mirror and camera so you have a clear view of the subject in the viewfinder.

• Silver birch, with golden leaves which can be isolated against the sky by pointing the camera up.
• Vast, ancient oak trees, with acorns and ivy-covered trunks, outcrops of fungi and woodpeckers.
• Beech trees, with smooth bark, triangular brown nuts (known as beechmast) and beech tuft fungus.
• Horse chestnuts with enormous fans of leaves and nuts ("conkers").

Collect the fallen fruits and foliage for a "forest floor" arrangement or float golden leaves in a puddle to isolate them.

Preparing for winter In autumn, squirrels and other small mammals put away stores of food for the winter. If you sit still and observe squirrels through binoculars you see where they hide their food. It is a popular misconception that squirrels hibernate: they don't. In winter, they rely on their stores, which they

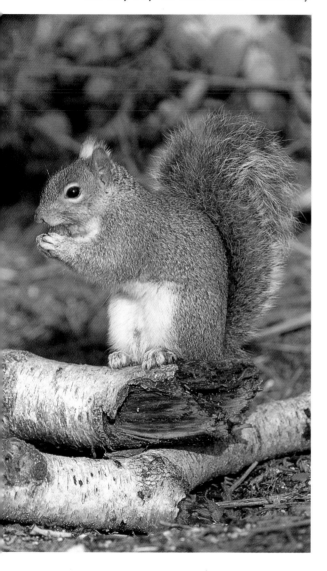

Trouble shooter

Q How do you shoot lightning?

A Be prepared. First, read the signs: hot humid weather, low drawn-out rumbles of thunder and brooding storm clouds Next, get into position with the camera on a tripod beside a large window with a view of the stormy sky. Count the length of time in seconds between the flash of lightning and attendant thunder claps, then divide by five (the sound of thunder travels about ⅕th mile per second).

Put the camera on "Bulb" or the "B" setting and hold the shutter open while the lightning flashes. In effect, the lightning makes its own exposure against the dark sky, so there is little risk of overexposure.

Beware standing outdoors in flat areas: lightning is attracted to tall objects connected to the earth and, it may come to earth through you!

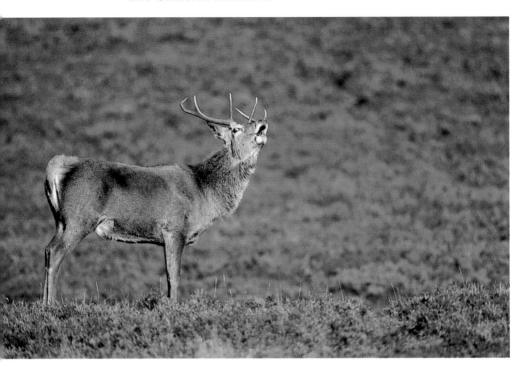

ABOVE *October is the best time of year for deer pictures in the wild, as stags rut and bellow in preparation for mating. Also when foliage is scarce on the higher slopes, they're more likely to come down to the valley floor in search of food. Don't get too near though.*

sniff out, and on supplementary feeding by kindly humans. If you see wild animals foraging in autumn, give them a bag of plain monkey nuts in exchange for a photograph.

Misty vistas Autumn mornings are typified by a blanket of mist, especially in sheltered, low, wet areas such as river valleys and water meadows. As the sun rises and becomes hotter, the mist evaporates.

Use misty conditions for stark shots of tree silhouettes looming out of the gloom, shooting into the sun. Compose your shot around an attractive color contrast: pink sun-orb against gray landscape. You need a tripod in dim conditions and perhaps a stop of exposure compensation to avoid underexposing the tree.

Best of all, head for high ground to photograph the mist from above, in clear sunshine.

Picture Pointers

■ Shooting foliage on the branch in breezy weather, ask a friend to stand just out of shot holding the branch still.

■ For superb, high-impact foliage pictures, use the fact that leaves are translucent. Shoot them backlit by sunshine by facing the light but frame the scene so you avoid getting the sun in the frame.

ABOVE *Berries, such as these blackberries, aren't just good to eat they're great to photograph too, especially framed by leaves with autumn hues.*

BELOW *Misty mornings are best for photos of autumn woodlands. Set up a tripod before to avoid camera shake in the low, slanting light.*

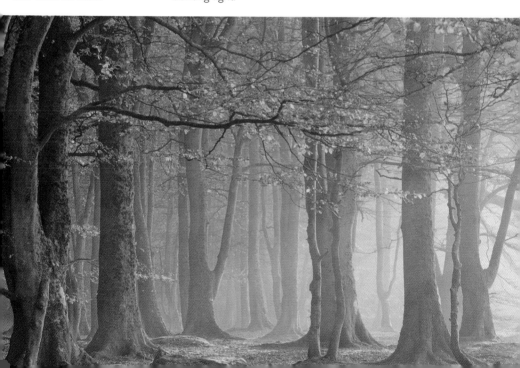

The Seasons: Winter

BELOW *Hoar frost transforms the plant world, tracing each berry, branch or blade of grass with delicate white crystals.*

Winter signals a migratory or dormant period for many birds and mammals. Bees stay in the nest and consume honey stores; toads, lizards and snakes burrow into the soil; bats, bears, racoons and mice grow fat before hibernating. The short days and lack of food and warmth mean tough times for most species, making it ideal for luring animals nearer to your camera with bait.

Death and decay Bare branches and snow-covered countryside are spectacular subjects for bold, graphic compositions in winter. Use skeletal lower boughs to frame, within the wider viewfinder frame, the wintry scene. Open farmland is particularly good for tree pictures like this, as the wide spaces isolate trees against the sky.

Faced with a dull, white, overcast winter sky, liven it up with a subtle, graduated color filter, like gray or pale blue. Graduated filters are half-colored, half-clear, with a subtle color fadeout effect in the middle. If you hold the filter carefully in front of the lens while the camera is on a tripod, you can take the picture so only the sky is colored, for great effect.

Remember to take one shot without the filter as well, to be certain you have the best version.

Frost and ice From a photographic point of view, frost offers an inexhaustible source of potential forming various shapes: fan, needle, scales and, on ice, its feather patterns. Look for leaf veins, spiders' webs and frost on icy surfaces. Use the zoom to crop the composition tightly, then set up your own frosty pictures using indoor items left out overnight. A damp cabbage, wet bouquet of flowers or even a pair of recently washed denim jeans will yield a fascinating study of the effects of frost for your camera! Try shooting the scene with and without an 81B or C warm-up filter to counteract the cold, blue light of a frosty morning.

Camera Skills

■ Shooting bright, sunlit snow lures the camera towards underexposure. Add a stop of exposure compensation if your camera offers it, unless you want to create a tree silhouette.

BELOW *Low winter sun brings contrast problems. Exploit the sun with silhouettes of backlit trees.*

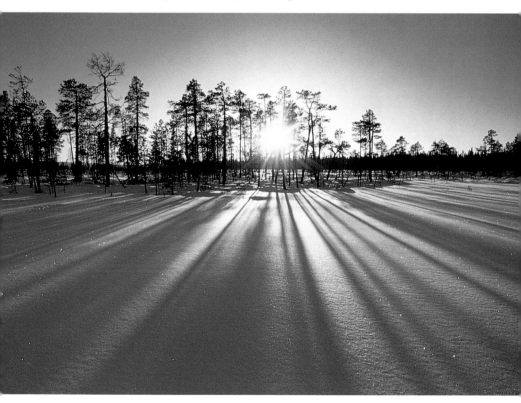

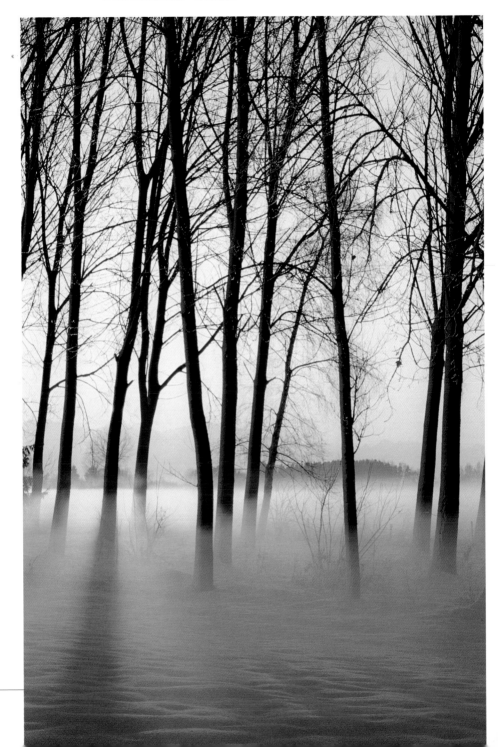

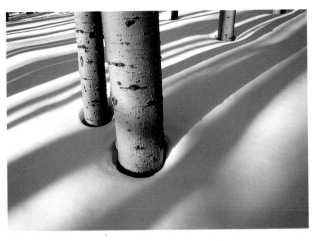

LEFT *Add a stop of exposure compensation if your camera offers it, as this keeps white snow looking white in sunshine.*

BELOW LEFT *When the snow melts during the day and then refreezes overnight, icicles are formed. Get out early the next morning to catch them lit with morning sunshine.*

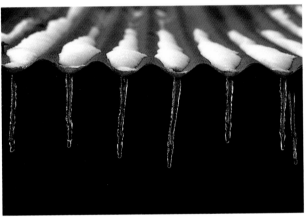

Do's & Don'ts

■ Winter is a great time for practising your technique and concentrating on captive animals. Do visit your local birds of prey (or raptor) centers, zoos and other conservation centres.

■ Do use the winter months to build a nesting box for your garden birds in spring to rear their young.

Sunlit icicles are another source of inspiration at this time of year. In a cold spell, watch the eaves of houses and sheds and panes of greenhouse glass for icicles and other interesting formations. Just as frost photographs can be constructed for the camera, so can pictures of icicles. Put interesting leaves or wet flower blooms in a bowl covered with water overnight and, providing the night was freezing and breezeless, you will find the subject frozen solid into place. (If the subject moves during the night or breaks the surface tension of the water, it may not freeze.)

FAR LEFT *The winter landscape can look stark and somber, an effect which is softened by morning mist.*

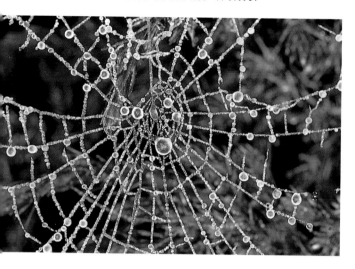

LEFT *Cobwebs are largely invisible throughout the year until the first frost or dew fall. These conditions reveal the skeins as an intricate pattern of diamond beads.*

Picture Pointers

■ If cold or wet weather brings them indoors, catch those long-legged spiders with a piece of firm card and a jar. With the spider temporarily captive, select macro setting to get close-ups but do not use flash as this will flare off the side of the jar.

■ If you have no macro mode, load up with print film and keep the subject sharp in frame by keeping the lens at a distance from the subject. Keep the spider at or beyond minimum focusing distance.

Shoot in the early morning before the sun has risen and melted the ice, taking care not to jog and dislodge the subject. Use fill-in flash, with the camera on a tripod, to perk up the natural colors.

Wild animals in snow Although winter is a period of reduced wildlife activity, there are some species which are active all year round – hunting for food in winter, and leaving tracks in the snow. In remote upland areas, deer and wild mountain goats come down to graze on lower slopes, creating opportunities for photography.

Most birds and mammals retain their normal coloring in winter, but gain an extra thick coat to counter the cold. Mountain hares, however, turn white as winter camouflage against predators (such as eagles and buzzards) in snow. Hares and wild rabbits are extremely camera-shy, so you need lots of patience. Build a blind or hide (see page 48) in a mountainous area where you have seen tracks (identified by the long stride and absence of toe or pad marks due to hairy soles) or use your car as a blind and sit and wait. Make sure you take a hot drink in a thermos.

Trouble Shooter

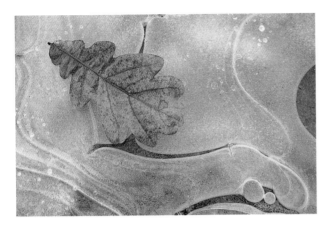

TOP and ABOVE *Oak leaves trapped under water will become frozen on a cold winter's night. Why not experiment with a few alternative set ups, for instance, freezing domestic household items (such as an old pair of woollen gloves) by leaving them outdoors in a bucket of water.*

Q What's the best way to photograph birds in winter?

A If you have a bird that regularly visits your garden, bait an area with dead worms or other small insects and wait to see where it perches. Keep up the baiting practice. The bird may visit at the same time every day so you can set up your camera pointing at the area just before it is due, although you must allow it to get used to the camera before taking pictures. Once used to the bait and camera, you can start taking pictures, using a 10 yard pneumatic cable release with adapter (or infra-red remote control handset if your camera has one).

Do not be put off by failure. The bird is bound to be startled if you have the flash on. First leave it off, get the results processed and then try Fill-in or Auto next time if the results are blurred.

Jargonbuster

APERTURE: this refers to the window inside the lens which lets light through to reach the film inside the camera. The size of this window is varied automatically in most compact cameras, according to how much light is available. For dark scenes the camera will select a larger aperture to let sufficient light through onto the film to make the correct exposure. Aperture sizes are measured in f-numbers.

AUTOEXPOSURE: this is the system which allows the camera to control exposure automatically. The camera's light-sensitive circuitry is able to measure the amount of light reflected by the scene in the viewfinder and thus evaluate the shadows, mid-tones and highlights to choose average exposure settings in the split second as you release the shutter button.

AUTOFOCUS: this is the system which allows the lens to focus on the subject automatically, using either an infra-red beam or image contrast to dictate where the precise point of sharp focus lies. Focusing accuracy is governed by the number of set focus positions available, known as focusing steps.

BEANBAG: a useful means of wedging a camera stock still on top of a wall, table or chair during a long exposure. If you take a portrait without flash or a tripod you run the risk of encountering camera shake. A beanbag will help you avoid camera shake as a smaller and less obtrusive alternative to a tripod.

CAMERA SHAKE: this occurs when the camera moves during an exposure and is most commonly caused by accidental jogging as you press the shutter button, or through body move-ment such as breathing. In dull conditions your camera may select a shutter speed that is too slow for sharp results; in such cases, use a tripod.

CONTRAST: this refers to the tonal range in a scene. In bright conditions, such as midday in summer, contrast is high and shadows are very black and dark. Conversely, in overcast conditions, contrast is low, and the tonal difference between shadow and highlight is less marked.

CROPPING: often pictures are spoilt by having too much wasted space in frame. This can be removed by "cropping" closer to the subject at the enlargement stage or (preferably) at the picture-taking stage. Use the viewfinder to judge how close you can safely move towards your subject without encountering parallax error.

DAYLIGHT BALANCED FILM: ordinary films are balanced to a colour temperature of 5500K. This means they will give neutrally-toned results in noon sunlight, but when the colour temperature is lower such as at 3200K (ie the colour temperature of domestic tungsten light bulbs) the results will appear orange.

DEPTH OF FIELD: this is the band of sharp focus in a picture, surrounding the focused point selected by your AF (autofocus) sensor. It is possible to exploit depth of field to turn a portrait background out of focus – select the telephoto end of your zoom and lock the focus on your subject's eyes. Telephoto lenses are designed to give shallower depth of field so the background will automatically go out of focus, especially if it lies at a great distance from your sitter.

DX-CODING: the computerized system inside the film loading bay at the back of the

camera that reads the film speed and number of exposures available automatically.

EXPOSURE: the process of recording an image from life onto a light-sensitive surface, such as photographic film. Photographic exposures are created using a camera with a shutter and an aperture. These limit the amount of time allowed for light to reach the film.

EXPOSURE LOCK: the camera feature which allows you to hold and lock. one light reading in the camera's memory while altering the composition. This is useful in conditions with high contrast, as you can take a light reading from a neutral-toned area by pointing camera at it, lock this reading into the memory, and reframe the shot to the more contrasty scene.

FILL-IN FLASH: the flash mode designed for use in bright sunshine which allows you to add a small blip of light into shaded parts of a scene without overexposing the image.

FILM SPEED: the ISO rating of your film refers to the film's sensitivity to light or the film speed. Higher ISO ratings are more sensitive to light, so you can use them in dim conditions.

FILTERS: these are usually made of light-weight plastic or resin, sometimes glass. When placed over the camera lens they alter the color of a scene or create special effects such as softfocus and multiple images. You can even use a strip of black stocking over the camera to make a DIY soft focus filter, but if you are using a pure color filter, it must also cover the camera's light-metering sensor so the loss of light is accounted for. Do not be tempted to use graduated filters as these will cause overexposure.

FOCAL LENGTH: this is the measurement which refers to the length of your camera's built-in lens. It refers to the distance between the front of the lens to the film plane inside the camera, measured in millimetres. If your camera has a fixed focal length it will probably be a short focal length bet between 28mm and 35mm. If your camera incorporates a zoom, it could range from a short focal length such as 38mm right up to 70mm or even 140mm at its longest extension.

FOCUS LOCK: similar to a camera's exposure lock, this feature is controlled by half depressing the camera's shutter button. It is very useful for off-centered subjects, as most autofocus sensors work by latching onto the central section of the image. Point the camera at the subject, gently press the shutter button half way (without taking the picture) then turn to reframe the shot so the subject lies off-center as planned.

INFINITY MODE: this feature allows you to keep a scene sharp from front to back, gaining maximum depth of field. It is ideal for landscape scenes taken with a tripod.

ISO: this stands for "International Standards Organization" – the authority that calibrates film speeds to ensure they are the same all over the world so that results can be predicted.

LCD: these initials stand for "Liquid Crystal Display," and refer to the grey-green tinted window often found on top of the camera body, which tells you certain useful information about the status of the camera. Most commonly you will be able to tell what frame number you are on/how many frames are left; whether a special exposure or compositional mode has been selected; when the battery is running low and whether the flash has been turned on or off.

LENSES: there are many sophisticated lenses on a compact, allowing reflected light to pass through to the film inside, shaping and bending it at particular angles to achieve different

ends – in a similar manner to the lenses in a pair of spectacles. The viewing lens helps you see the image while the taking lens allows light to strike the film to record the image.

LIGHT METER: this essential and sophisticated part of any automated camera is located inside the camera body. To activate it, all you need to do is switch the camera power on and point the camera at the subject so it can measure the amount of light reflected by it. As you press the shutter button to take a picture, the compact call assess and adjust the exposure settings (aperture and shutter speed) in relation to the film speed, to ensure a correct result.

MACRO MODE: many compacts are designed with a built-in macro facility. This allows you to get closer than normal to small subjects such as flowers and babies to better fill the image frame.

OVEREXPOSURE: this occurs when too much light has reached the film, creating a pale result. For instance, when the subject is too close to theca camera in dim conditions, the flash burst can sometimes overpower it and create a harsh image without detail in the highlight areas.

PARALLAX ERROR: this refers to the problem of accidentally cutting off the top section of the subject, such as the top petals of a flower or the top of somebody's head. It happens when you get too close to a subject – the viewing lens shows a slightly higher vantage point compared to the view recorded by the taking lens.

RED-EYE REDUCTION: red-eye occurs when flash strikes the blood vessels at the back of the retina. Many cameras offer a pre-flash facility or bright light to encourage a portrait sitter's pupils to contract before the main flash fires to make the exposure.

SHUTTER SPEED: to make any photograph, the camera has an internal shutter mechanism which opens to allow light to reach the film. The speed with which it opens and closes dictates the length of the exposure, which is usually measured in fractions of a second.

SINGLE-USE COMPACTS: there are many designs available – with and without flash, splashproof, panoramic and even those offering a 3D picture. All you have to do is use the film and send the whole camera in for processing. The lab will return your pictures in the usual way.

TELEPHOTO: this is the longest end of a compact camera's zoom range, and focal lengths of 70mm, 85mm and 105mm are typical. Use the telephoto end of your zoom to enlarge a subject in frame, throw the background out of focus beyond depth of field, and to better isolate a portrait sitter from her surroundings.

TRIPOD: this is the photographer's three-legged friend. Using a tripod holds the camera steady to prevent camera shake.

UNDEREXPOSURE: this occurs when too little light has reached the film, creating a dark result. For instance, when the subject is too far away from the camera in dim conditions, the flash burst can sometimes fail to reach it, thus creating a dim result.

WIDEANGLE: this refers to the short focal length offered by most fixed lens compact cameras. It is also the correct term for the shortest end of a zoom compact's lens range, and focal lengths of 28mm, 35mm and 40mm are typical. Use the widest end of your zoom to capture the beauty of a panoramic vista, to keep a tall building within the image frame if you cannot stand back, and to maximize depth of field to keep fore- and background sharp.

Index

Index/Acknowledgements

PICTURE ACKNOWLEDGEMENTS

Front cover Zefa Picture Library.
Back cover Laurie Campbell top, Image Bank/Laurence Hughes centre, Bruce Coleman/Stephen Bond bottom left, Roger G. Howard bottom right.
Steve Bavister 58 top.
Niall Benvie 6 top, 9 right, 10, 27 top, 34 bottom, 40, 50 bottom, 74 /75, 85 bottom.
Laurie Campbell 3 top right, 14, 15, 17, 18, 20 bottom, 26 bottom, 29 top and bottom, 68 top, 70 top, 71, 82 bottom, 84.
Bruce Coleman Ltd Erwin and Peggy Bauer 4 /5, Trevor Barrett 32, 54 /55, 69 bottom, Jane Burton 45, George McCarthy 48, Eric Crichton 60 bottom, Peter Davey 57 top, Geoff Dore 27 bottom, 68 bottom, M P L Fodgen 47, Jeff Foott Productions 52 bottom, Jeremy Grayson 77, Halle Flygare Photos Ltd 7 left, Pekka Helo 26 top, Janos Jurka 19, Stephen J Krasemann 13 top, George McCarthy 30 bottom, 33 top, 42 top and bottom, William S Paton 20 top, 30 top, Dieter & Mary Plage 53, Eckart Pott 33 bottom, Allan G Potts 82 top, Raimund Cramm 25, Hans Reinhard 85 top, Michel Roggo 67 bottom, Leonard Lee Rue 7 right, 39 39, Kim Taylor 43, 91 bottom, Uwe Walz 31 top, 61 bottom, Rod Williams 59.
Ewa-marine/Cameras Underwater 63.
Malcolm Freeman 51.
Mark Hamblin 13 bottom.

Robert Harding Picture Library 2, 6 bottom, 41 bottom, 52 top, 57 bottom, 70 bottom, L Bond 23 bottom, Martyn Chilmaid 80 top, Ian Griffiths 21, Julie Habel 72 top, David Hughes 3 bottom.
Paul Hicks 50 top.
Roger G. Howard 1, 78, 79 top, 86, 89 bottom. Image Bank 46, Tim Bieber 34 top, Fernando Bueno 64, James Carmichael 60 top, Flip Chalfant 9 top, Guido Rossi 72 bottom, Laurence Hughes 54 bottom, Paul McCormick 38, Michael Melford 8 left, Kaz Mori 74 top, Joseph Van Os 24, 56, Derek Redfern 90, Den Reader 91 top, Marc Romanelli 89 bottom, Laurie Rubin 16, Ulli Seer 87, Lynn M. Stone 36 top, Harald Sund 79 bottom, Peter Turner 22, Turner & De Vries 37, Doc White 28.
Longleat Enterprises Limited 58 bottom.
Linda Pitkin 65 top.
Brian Pitkin 62 top and bottom.
Tony Stone Images 83, Daniel J Cox 12, David Carriere 80 /81, Dirk Degenhardt 88, John & Eliza Forder 72 /73, Alan Hicks 23 top, Jan Kopec 61 top, Michael Orton 36 bottom, James Randklev 81 top, John Shaw 66, Richard H Smith 41 top, Rob Talbot 35, Darryl Torckler 67 top, Kim Westerskov 65 bottom.
Jeff Tucker 76.
Liz Walker 8 right, 11.
Wildfowl & Wetlands Trust 49 top, Joe Blossom 49 bottom.
ZEFA Picture Library 3 top left.